GOLD BOXES

From The Collection of

Rosalinde and Arthur Gilbert

Géza von Habsburg-Lothringen

Published by
R. & A. Gilbert
Copyright © 1983
R. & A. Gilbert
ISBN 0-9610398-0-9

Printed in an edition of 5,000

Photography by Lawrence S. Reynolds *Los Angeles*
Printed by White Brothers
(Printers) Ltd., London

Cover Illustration: No. 38—The Frederick the Great Snuff-Box

CONTENTS

Catalogue of Boxes

FOREWORD

In discussing an outstanding assembly of gold boxes such as we have before us, it would be pointless merely to mouth high-sounding tributes and generalities; the box is the thing and faced with an elaborate object which is the result not only of inspired design but of the most painstaking application to detail on the part of, very often, several craftsmen, any appraisal to be valid must be particularized and specific.

I have chosen to describe a limited number of examples which have especially attracted me in order to provide some sort of prelude to the Catalogue which follows. This method follows the picturesque theory that it is not necessary to eat the whole cow in order to find out if the beef is tough. The fare offered for our delectation here is succulent, appetizing and in every case, beautifully prepared.

It is an anthology of wide-ranging scope which illustrates most of the complicated and fascinating techniques employed by European goldsmiths during the last two hundred and fifty years. The apogee of the craft of gold box making was reached during the central decades of the eighteenth century when a lively freedom and apparent ease of expression demonstrated what has been traditionally described as "the art that conceals art".

The designer's original drawing is thus exactly translated in terms of gold, enamel or stone without sacrificing any of the first inspiration or what Walter Sickert used to call the letch and without any of the ponderous technical encumbrances which later too often imprisoned or pinned down any free flight of the imagination.

Paris emerges clearly as the nerve centre which directed the main current of ideas and it is hardly surprising that we refer to this rich period as *le siècle de la tabatière*.

It would be difficult to conjure up a purer distillation of the spirit of this magic period than the engraved rectangular snuff box by Jean-François Breton of 1753 (no. 42) with its Boucher decor of pale enamelled flowers, bright leaves and, depicted on the cover, Apollo with a lyre among winged cherubs in a setting of clouds from which radiate sunrays of softly twinkling diamonds.

Jean Ducrollay, probably the most celebrated of the Paris goldsmiths, is represented by a particularly chic gold brick of a box (no. 43) which opens in the usual way at the top but is further endowed with a hidden compartment below where, presumably, the owner could secrete his favourite snuff which he kept for his exclusive use. The box itself, dated 1754, is decorated with an all-over trellis of engine-turning which produces the impression of a large expensively wrapped chocolate. The *tour à guillocher* which revolutionized the goldsmith's craft was a comparatively recent innovation and the makers of gold boxes obviously exulted in this latest tool which, to a large extent, replaced hand engraving and this box finds one of the greatest makers joyfully availing himself of a splendid new facility.

One of the special conceits dear to the Paris enamellers during the reigns of both Louis XV and XVI was borrowed from earlier architectural decorators who had painted walls to simulate marble and other figured stones. Perhaps the prettiest box in the collection is oval in form and was made in Paris by François-Nicolas Génard in 1763 and is enamelled *en plein*—that is, directly on to the main gold body of the box—with enchanting paintings of pet dogs and a cat, with between each cartouche, an oval plaque enamelled in faithful imitation of lapis lazuli. The use of a paler opaque blue enamel adds yet another dimension to this marvellous box (no. 44).

In the year of Louis XV's death, Melchior-René Barre designed one of the most richly decorated snuff boxes imaginable (no. 47). Another oval box, this one enamelled translucent golden-brown over an engraved chequer-board field, is surrounded by oval panels each one enamelled *en grisaille* with *amoretti* disporting themselves against opaque enamelled sage-green backgrounds. Alternating between these are smaller circular panels each, similarly enamelled, with a trophy relating to the arts or sciences. The box itself is lavishly hung with chased floral garlands in golds of colour.

There are no fewer than four boxes, each in a completely individual manner, by one of the most inventive of the Parisian goldsmiths, Gabriel-Raoul Morel who is known to have been active from 1798 to 1813. One of these, a rectangular cagework box is set with dark panels of *lacque burgauté,* with mother-of-pearl, coral, ivory and tiny coruscating squares of gold inlaid in mosiac technique depicting birds and flowers (no. 65).

Sir Sacheverell Sitwell, in describing a detail on the cover of this sumptuous box, which once formed part of a Rothschild collection, points out that it "appears to wonderful advantage in the glittering tail feathers of the golden cockerel".

English gold snuff boxes are very well represented. The sheer appeal of the simple early eighteenth century oval gold box emblazoned with a boldly red, white and blue enamelled coat-of-arms (no. 12) is quite irresistible—it has a tactile quality which clearly demonstrates a fact which is often forgotten, that boxes of this period were designed to be taken up in the hand and worn about the person whereas many of those made during the last quarter of the century were to be placed on tables.

Another of the early and most delicately conceived is rectangular and is set with rubies and diamonds and takes the form of a scrolling cagework of chased gold enclosing mother-of-pearl panels, the gently curved walls are overlaid with architectural motifs and on the cover two figures approach an idealized temple (no. 14).

A far more robust rectangular box is set with a profusion of moss agates within chased and reeded rococo borders and contains not only a watch, but a concealed painting with an elaborate *automate* which functions perfectly. This *tour de force* is entirely characteristic of the ingenious fancy of James Cox (no. 19).

In the nineteenth century, the English taste, in common with the rest of Europe, sobers up and devotes itself to more conventional designs, more magnificent chasing and many varied patterns of machine engraving. A. J. Strachan is the most prolific of several goldsmiths who have provided splendid examples which appear in this collection.

One of the most austere yet distinguished boxes here is either from the hand of a craftsman named Kolbe or derives from a firm in St. Petersburg of that name. *Quatre-couleur* gold scenes are applied to the main body of this oval snuff-box which is of dull grey-black steel engraved to give the impression of the niello work so beloved of the Russians. The effect of the coloured golds set against this sombre lead-coloured background satisfies a peculiarly dry taste (no. 8).

Having for some years admired this particular owner's justly celebrated collection of mosaics, it is hardly surprising to find the work of the Dresden master of *zellenmosaik,* Johann Christian Neuber, liberally represented here. The circular snuff-box from his hand with a seated dog on guard on the cover and a multi-hued butterfly lightly poised on the base, both depicted against closely set backgrounds of rich lapis lazuli *tesserae,* is a splendid example (no. 41).

The box itself is further embellished with Indian red cornelian pellets, bloodstone leaves and turquoise forget-me-nots, a decor much employed by this great lapidary.

The oval example with the portrait of Mlle de Valois is more formal but also owes its magnificence to an unusually generous use of lapis lazuli (no. 39).

One visited Dresden in the late eighteenth century to pick one's Neuber box much as, on the Grand Tour, it was mandatory for a gentleman to visit Venice and acquire, if not a Canaletto or a Guardi, at least one canvas from the *vedute* school showing a view of La Serenissima.

An attractive box in the collection is rectangular, carved in an ochre-coloured jasper and girdled by an unusually simple gold bezel engraved with a wave pattern. It is encrusted with arrangements of fruit carved with loving concern for detail in high relief from various stones of subtle and harmonious colouring (no. 37). This work is typical of the Hoffmann workshop in Berlin.

There are several European boxes of great historical significance which I have not discussed in this brief note, but there is no box which has a more pressing claim upon our attention than the rare jewelled and encrusted snuff-box made for Frederick the Great between 1760-1765 (no. 38).

It is well known that he lavished more genuine affection upon his splendid snuff-boxes than upon any of his valuable paintings not excluding the works of Watteau for which he had a special regard.

This large table box, each wall ablaze with an unending river of diamonds flowing round a bed of mother-of-pearl which seems to reflect the pale flush of a dawning sky, encrusted with carved stone flowers and leaves, must have stood high on his list of favourite possessions.

Jean-Guillaume-George Krüger, who designed most of these Potsdam boxes and was the creative dynamo energizing their production, was born in London in 1728, trained and worked in Paris and in 1753 answered a call from Frederick to move to Berlin where he founded and guided what has come to be known as the Berlin School.

The great strength of this collection is the fastidious dedication to quality which has informed its selection. To point out that the owner has been advised and influenced at all times by the London *savant* Martin Norton will go far towards explaining the success of this endeavour.

The superb photographs which illustrate the Catalogue provide those of us who interest ourselves in these elegant personal accessories of an age gone by with an acceptable consolation prize.

A. Kenneth Snowman

INTRODUCTION

A Short History of the Gold Snuff-Box

T he early history of snuff and snuff-boxes has been thoroughly researched and described in a number of monographs and goes well beyond the scope of this specialised catalogue. Suffice it to say that the origin of the snuff-box lies in the 17th century. Snuff-flasks and boxes in a large variety of materials, including wood and brass, existed in all countries well before gold snuff-boxes made their appearance.

In France, the cradle of the gold snuff-box, contemporary sources mention their use during the reign of Louis XIV, despite his declared dislike of the habit of snuff-taking. This sovereign presented only *boëtes-à-portrait,* no *tabatières,* to those he favoured. This Louis XIV *boëte* was jewelled and decorated with the royal effigy. It is to his Prime Minister Louvois that the honour must go to have possessed one of the first snuff-boxes in Paris which, according to Mme de Genlis, was heart-shaped and made of lacquer. Others, such as the Duc d'Harcourt and the Maréchal d'Huxelles, soon followed suit. Due to the King's decree to have all silver and gold melted down in order to finance his expensive wars, and also to the austerity of the French Court under the influence of Mme de Maintenon, virtually no gold snuff-box prior to 1715 has survived.

The earliest French gold snuff-boxes date from the *Régence* period. They are simple gold-set mother-of-pearl boxes. The first *tabatière* to be mentioned in the *Régistres des Présents du Roi* occurs in 1726. At this time the snuff-box becomes an object of political utility. Daniel Govaers' boxes made for Louis XV (earliest extant examples in the Louvre and in the Firestone Collection, both dated 1725/6) were gifts to ambassadors. The exceptional box by Juste-Aurèle Meissonier dated 1728/9 commemorates an historic occasion. Most of these royal presents, which are found in large numbers in the *Régistres* and the *Menus Plaisirs,* were extremely costly. They were lavish presents, a number of them decorated with more than 500 diamonds (*Régistres* 1776, 1777). Of these, the box presented by Louis XV to the Marquis de Scotti, Envoy of Parma, which cost 129,582 *livres,* holds the absolute record (*Régistres* no. 216, March 28, 1720).

A perfectly accepted custom was the conversion of presentation boxes into their equivalent monetary value. The *Régistres* (1775) mention a typical case of one snuff-box presented twice running to the Count de Viri, Ambassador of the King of Sardinia, and returned by the Count to the jeweller against a refund of 25,000 *livres.* In some cases, returned boxes were altered by the jeweller (a box costing 10,608 *livres* which was originally primrose yellow was prepared for renewed presentation in scarlet enamel (*Présents du Roi* no. 444).

By the mid–18th century most courtiers and their ladies indulged in taking snuff, vying with each other in more and more lavish acquisitions from the *marchands-merciers*. Mercier in his *Tableau de Paris* (1781, Vol. I, p. 297) writes: *"On a des boëtes pour chaque saison. Celle d'hiver est plus lourde, celle d'été est légère. On a poussé cette recherche jusqu'à changer de boëtes tous les jours. C'est à ce trait qu'on reconnaît un homme de goût. On est dispensé d'avoir une bibliothèque, un cabinet d'histoire naturelle quand on a trois cent tabatières et autant de bagues"*. The Prince de Conti who died 1776 left 800 snuff-boxes. Frederick the Great is said to have owned up to 1,500.

Many were the detractors of snuff-taking in the 18th century. Furetière in his *Dictionnaire* (1727) wrote *"C'est une manière de se remplir le nez de tabac sous prétexte de purger les cérosités du cerveau. Cependant l'usage en a tellement prévalu que tout le monde en prend presque continuellement jusqu'aux femmes et aux filles même. C'est quelquechose de dégoûtant de voir une femme ou une fille qui a le nez tout barbouillé de tabac"*.

The *Siècle de la Tabatière* found many uses and original materials for its snuff-boxes. Primarily they were carried in pockets to show off in dandy-like fashion. At home they were displayed in showcases, on tables and mantelpieces. They were made of copper, brass, papier-mâché, leather, glass, wood, cardboard and silver if intended for the less rich, and of marquetry, steel, porcelain, mother-of-pearl *burgau*, ivory, Vernis-Martin, lacquer, hardstone and gold for the aristocracy. Later boxes included mounted miniatures and panels of mosaic, enamel and painted glass.

The earliest French gold snuff-boxes are cartouche-shaped, often heavily chased with scrolls and encrusted with diamonds, as in the examples by Daniel Govaers mentioned. The decade between 1745 and 1755 is the apogée of quality and style for the Parisian box. Boxes by great makers such as Jean Ducrollay, Noël Hardivilliers, Michel-Robert Hallé and Jean Frémin are justly considered today as representing the epitome of the French *Grand Siècle*. Their microcosmos reflects all the elegance and invention of one of the most pleasure-loving of societies. A predilection for *Chinoiseries* deeply marked all art of this period. Some of the finest boxes are inset with mother-of-pearl plaques encrusted with Chinese, mythological or genre subjects in hardstone, others with obviously rare Japanese lacquer panels. Gold boxes were enamelled in *basse-taille* or over waved and embossed backgrounds with flowers and animals.

Email en plein makes its appearance, with many an anonymous painter copying or adapting to his need well-known masterpieces of earlier or contemporary masters, such as Teniers, Le Sueur, Coypel, Watteau, Boucher and Greuze. The best master goldsmiths of the period from 1755 to about 1775 are Louis Roucel, Jean-François Garand, Louis-Philippe Demay, Jean Formay, Henri Bodson and Jean-Joseph Barrière. Some, such as Jean George, Jean-Marie Tiron and Paul Robert specialize in heavy chased gold snuff-boxes with hunting, shipping or *basse-cour* subjects. Others in setting miniature paintings by van Blarenberghe and his school in gold.

During the reign of Louis XVI, snuff-boxes become more stereotyped, mostly oval or circular in shape. They are enamelled with monochrome panels on engine-turned backgrounds, many with mythological, amatory or portrait miniatures on their covers. Jean-Joseph Barrière and Joseph-Etienne Blerzy are the foremost exponents of this style. Blerzy and Adrien-Jean-Maximilien Vachette produced large quantities of snuff-boxes until up to the Revolution. In the troubled years after 1789 most great gold- and silversmiths disappear. A new lozenge hallmark system is introduced but not applied with the necessary severity, often no longer permitting an easy identification of goldsmiths. Vachette (active until 1835), Blerzy and Charles Ouizille bridge the gap between the pre- and post-revolutionary periods. Due to Napoleon's political influence throughout Europe, the Empire style (and with it the snuff-box) now overruns the Continent. Alexandre Deferre, Pierre André Montauban and Gabriel-Raoul Morel, together with Vachette, belong to the last generation of great snuff-box makers, bringing this period to a close.

In *England* the earliest boxes date from 1710/20. They are plain and shallow, mostly oval or rectangular, their covers embossed, engraved or painted with coats-of-arms or monograms. Following the accession of George II to the throne, the style of boxes becomes predominantly Germanic. This mid–18th century box is cartouche-shaped and elaborately chased. With exceptions such as George Michael Moser whose engraved signature we find on outstanding examples, the names of only a few artists are known to us. English snuff-boxes of this period are rarely hallmarked as many are made of gold-mounted hardstone not requiring marks. These can hardly be told from their Germanic counterparts. Of those bearing marks, many initials have not been identified with certitude. This problem of attribution still characterises the reign of George III when a more national style asserts itself. Oval boxes comparable to Parisian Louis XVI examples, tend to become more elongated, often even navette-shaped. Chased or enamelled subjects fill the entire spaces on the panels. Many of these boxes are set with miniatures by Plimer, Smart or Bone. The most renowned box-maker of this period is James Morriset.

With the elaborately chased products of A. J. Strachan, John Northam and their contemporaries, the English box follows the mainstream of English silver during the first decades of the 19th century.

In *Germany* no gold box seems to pre-date the mid–18th century. Silver, enamel or porcelain boxes were being produced in centres such as Augsburg, Dresden and Meissen. Unmounted hardstone and enamel panels were often sent abroad for mounting.

The German gold snuff-box was virtually "invented" by Frederick the Great. Forever dependent on France for his taste but always eager to surpass Paris, the King commissioned a series of snuff-boxes without parallel in history. Initially made by goldsmiths of English (Jean-Guillaume-George Krüger) and French (Daniel Baudesson) origin, later by craftsmen trained locally, these boxes are masterpieces combining the art of the jeweller, gold chaser and hardstone-cutter. Lavish to an

unheard of degree, they are rarely made out of gold, most of them are in hardstone (agate or chalcedony) profusely encrusted with gold applications and large numbers of precious stones. Although most goldsmiths active for Frederick are known to us by name, only in rare instances can their products be attributed. Several hundred boxes belonging to this passionate taker of snuff are listed amongst his belongings but none of the few remaining can be identified with certainty.

Dresden was the German court with the greatest tradition for luxury. All alchemists, jewellers, hardstone-cutters, gold- and silversmiths were welcome to the Electors of Saxony. Of these, the most celebrated was Johann Melchior Dinglinger, to whom we owe the magnificent "Court of the Great Mogul". Saxon boxes are all in some way connected with the hardstone-cutting industry. The earliest anonymous productions were often shaped as animals or baskets carved in amethystine quartz or agate, their thumbpieces set with gems. One of the few box-makers of renown was F. L. Hoffmann who specialized in gold-mounted wafer-thin agate boxes encrusted with insects in polychrome hardstones. Heinrich Taddel made burnished gold boxes inset with landscapes and figures in *Zellenmosaik*. His son-in-law Johann Christian Neuber and Christian Gottlieb Stiehl were to invent the *Steinkabinettstabatière,* a snuff-box inset with a numbered assortment of local hardstones, sometimes containing an explanatory booklet in a secret compartment. Others are decorated in complicated hardstone patterns and inset with a central portrait or porcelain plaque.

Russia's tradition of gold boxes is almost entirely based on imported labour. The Russian snuff-box at the height of its development is large, chased in gold and often heavily encrusted with diamonds. Jérémie Pauzié, of Swiss origin, was both lapidary and gold-chaser. None of the lavish boxes in the Treasury of the Hermitage that are traditionally attributed to him are signed. Russia's equivalent to the Louis XVI snuff-box are the oval and circular boxes made by Johann Gottlieb Scharff for Catherine the Great. These are invariably inset with bands of diamonds around a central enamel medallion. The boxes of François-Xavier Bouddé also follow Louis XVI examples while the Genevese enameller and box-maker Jean-Pierre Ador is responsible for a number of boxes extensively painted *en plein* with elaborate mythological scenes or subjects connected with contemporary history. Many of his boxes are distinctly Swiss in flavour. Other artists such as F. J. Kolbe and Otto-Christian Sahler made only an occasional appearance in Russia. Amongst the exponents of the Empire style were Pierre Thérémin of Geneva and the Prussian Otto Samuel Keibel.

The *Austrian* gold box of the 18th century naturally gravitates around the Viennese Court. As in Germany, no Austrian gold box would seem to pre-date the middle of the century. Among the few known artists, Jean-Paul Kolbe was the most accomplished gold chaser responsible for exquisite boxes such as the Rothschild Collection box chased with a view of Schönbrunn. Philipp Ernst Schindler, trained as a porcelain painter at Meissen, decorated and signed a number of Austrian boxes

in a characteristic polychrome palette inspired by French contemporary models and based on well-known masterpieces by painters such as Teniers or Boucher.

The *Swiss* gold box originated in Geneva. As from 1760, goldsmiths and enamellers emulated the elegant productions of Paris to a degree that even today many of them cannot be told from the original. Swiss boxes are not, however, of the same perfection. Invariably gaudier, they lack the French sense of *raffinement* and are marked in a haphazard manner with imitated ("prestige") punches. Basically copying Louis XVI boxes by goldsmiths such as Barrière and Blerzy, they are "retardatory" in style, always a decade behind their counterparts. Few Geneva box-makers from before 1790 have been identified. They are known to us mainly by their recurring initials struck on a large number of boxes still extant. In the 1780's complicated automata make their appearance and are inserted in boxes, watches, telescopes and all sorts of amusing toys. After the French Revolution a more national style prevails: glossy colourful enamels decorate the lids of mainly flat rectangular, more rarely small oval or octagonal boxes. Presentation boxes become a speciality of Geneva, many copied from Empire originals. Towards 1820 Geneva becomes a major export centre for enamels. Large numbers of boxes are made for the Near-Eastern and Russian market. Later Neuchâtel churns out cartouche-shaped embossed presentation boxes set with diamonds, miniatures and enamelled cyphers for many European courts.

The origins of the *Italian* snuff-box remain somewhat nebulous. Cartouche-shaped tortoiseshell boxes inset in gold seem to point to a Neapolitan centre active around 1730. But apart from the occasional porcelain box, no others appear in Italy before the late 18th century. It may however be, that Italian boxes, unmarked and possibly similar in style to "Transalpine" models, remain hitherto unrecognized. Rome, with its crowds of tourists all in search of souvenirs, developed its micromosaic trade towards the end of the 18th century. Numerous Roman classical subjects, landscape and subjects copied from famous paintings are often inset in Empire-style boxes dating from 1800-1820.

The *Dutch* mid-18th century gold box is heavily chased and cartouche-shaped, very similar in style to contemporary English models. Typically Empire-style boxes make their appearance during the French Occupation.

Sweden and *Denmark* were both major centres in the production of gold boxes. Numerous were the goldsmiths in Stockholm, but none so outstanding as Franz Bergs. His cartouche-shaped chased gold boxes and his oval boxes decorated with dark blue *basse-taille* enamel scenes are without parallel in the North. In Copenhagen, Frederick Fabritius with his chased gold boxes and his later enamelled classicist scenes, was the best representative of his period.

The era of the snuff-box was virtually terminated by the middle of the nineteenth century although presentation boxes with Royal Cyphers were still considered appropriate gifts even well into our century. The cigarette-case, as developed by Carl Fabergé, rapidly replaced the snuff-box.

ACKNOWLEDGEMENTS

My special thanks in the production of this catalogue go to Madame Tamara Préaud of the Musée de Sèvres for her help with the box by Fossin (no. 66) and to Monsieur Serge Grandjean of the Museé du Louvre for astutely identifying the scene on the van Blarenberghe box (no. 68). I am also most grateful to Simon Bull for information on all horological problems and to Sotheby's for making their records available to me. I am furthermore indebted to my colleagues at Christie's for their patience regarding my numerous queries, but especially to Alexander von Solodkoff for background information on the Bouddé (no. 11) and the Korff box (no. 9), and to Miss Florence Daugny for her excellent research work in numerous cases. Messrs. S. J. Phillips of London have been helpful in providing information on the many boxes in the collections that have passed through their hands. Christopher Davidge of White Brothers has been forever practical in solving the manifold technical problems of printing. Miss Armgard Wüst sacrificed much of her free time typing the texts.

The
Gilbert Collection
of
Gold Snuff-Boxes

The Rosalinde and Arthur Gilbert Collection of gold boxes is an excellent example of how much of quality can be gleaned from the art market in a remarkably short while. The Gilberts are late arrivals to the gold box world. Their foremost interest—since their first acquisition in 1960—lay in mosaics. Their collection, now on view at the Los Angeles County Museum of Art, is the most comprehensive assembly of its type in the world. The same epithet could be given to the Gilbert silver collection specializing primarily in the art of Paul de Lamerie and of Paul Storr and his period.

Their passion for mosaics brought the Gilberts into contact with the realm of boxes. Coincidence would have it that the first mosaic they bought was set in the cover of a box by Vachette (no. 62). The mosaic collector assembled a large array of boxes set with Roman micro-mosaics mostly dating from 1790/1820 which give us a good insight into the wide distribution of such popular items throughout Europe, in Italy (no. 5), in Austria (no. 7), in England (no. 28), and France (nos. 59 and 62). In this sector the collection is remarkably well represented and only a few examples have been selected for inclusion here. A catalogue of the mosaics is at present in preparation.

The Gilbert Collection also contains an unusually large number of gold-mounted hardstone boxes, the best examples originating from Germany. Typical boxes by Neuber and his circle (nos. 39, 40 and 41), others from the workshop of Heinrici (nos. 35 and 36) and F. L. Hoffmann (no. 37) of Saxony, all demonstrate this *penchant*. A very recent acquisition is the magnificent Frederick the Great box (no. 38). This author considers its first viewing in the dungeon of an aristocratic castle as one of the highlights of his career. No illustration can give full justice to the opalescent sheen of its mother-of-pearl coating.

The widespread distribution of German (no. 56), and Italian (no. 60) hardstones throughout Europe is also documented by the Gilbert Collection. A series of hardstone boxes dating mainly from the 1760s come from England (nos. 14, 17 and 19), as does the unusual Blois watch-case mounted as a snuff-box (no. 13), the George II enamelled gold box and the superb triple snuff-box with enamels after Coypel attributed to Moser (no. 16). The English boxes range in date from 1710, with a Queen Anne box of singular elegance (no. 12), to an 1835 George IV box heavily embellished with chasing (no. 34). The choice of elaborately chased 19th century snuff-boxes goes hand in hand with the Gilberts' obvious predilection for ornamental silver wares.

From Geneva comes the historic Napoleonic box, surely one of the most lavish objects of its kind ever made in this city, set with a fine miniature of the Emperor by Isabey (no. 4), as well as a rare musical automaton tight-rope-walker box (no. 2), closely related to another with automaton ships, its Swiss mechanism set in a box by Blerzy (no. 54). The Russian section sports several documentary items including the box by Bouddé commemorating the erection of the statue of Peter the Great on horseback in St. Petersburg in 1782 (no. 11) and the recently discovered box of Baron Nicolaus von Korff lavishly enamelled with all the decorations he had received during his diplomatic career (no. 9).

The twenty-six boxes selected for the French section illustrate the development of the Parisian snuff-box during its most important century. The series begins with the aristocratic jewelled and enamelled box by Breton of 1753 (no. 42), includes highlights by some of France's best box-makers, Ducrollay (no. 43), Génard (no. 44), Tiron (no. 46), Blerzy (nos. 48, 54, 55 and 57), Le Bastier (no. 50) and Barrière (no. 51) to culminate in a most enlightening series of boxes by Vachette (nos. 52, 58, 62 and 63) and Morel (nos. 60, 64, 65 and 67), proving once more, if necessary, the high quality and elegance of boxes of the post-revolutionary period.

G. v. H.

Catalogue

Switzerland

1

AN OVAL ENAMELLED GOLD SNUFF-BOX, the cover with an oval miniature *en grisaille* of a Roman soldier and a lady within a frame set with rose-cut diamonds, the cover, base and sides painted *en camaïeu mauve* with sea-and landscapes and figures *in the manner of Joseph Vernet* on opalescent pink background, with opaque white and turquoise enamel borders, the frames chased with husks, the sides with suspended laurel swags and opalescent white oval discs.

8.5cm (3⅜ in) long, Geneva, circa 1780, maker's mark crowned EC, bearing French "prestige" marks (the charges of Fermiers Jean-Jacques Prévost and Julien Alaterre).

A group of five enamelled gold snuff-boxes in the Louvre (cf. S. Grandjean nos. 547-551, and pp. 442/3) bear an identical unidentified maker's mark. The copper plates on which the master goldsmiths' marks were registered in Geneva, were destroyed after the French Revolution and the annexation of the Canton by Napoleon in 1798. For this reason no maker's names can be identified with certainty. The Louvre boxes are all very similar in style. All of them, including our example, are stylistically close to originals of the Louis XVI period made in Paris circa 1770/80 by makers such as Jean-Joseph Barrière and Joseph-Etienne Blerzy (cf. S. Grandjean nos. 33, 37, 38, 39). French *camaïeu mauve* boxes on pink opalescent ground exist in a number of collections. One of the closest in style is another box in the Gilbert Collection (cf. no. 51 of this catalogue) by Jean-Joseph Barrière. For a Swiss box in the Louvre with similar *camaïeu mauve* scenes by the unidentified maker DM, cf. S. Grandjean no. 543.

The above-mentioned group of Louvre boxes nearly all bear the imitated date letter R and the *charge* of Fermiers Jean-Jacques Prévost or Julien Alaterre. All of these boxes, made in Geneva between 1770 and 1790, are not quite as sophisticated in quality and style as their French counterparts. It is not clear whether they should be considered as early fakes or just cheaper versions of their extremely expensive models. Their hallmarks, dubbed "prestige" marks, imitate Paris *poinçons* but always give themselves away by mixing the date letters of the *Maison Commune* and the respective *Fermier*. Moreover, they omit the *décharge* on the flange—the only mark of this type used is the much earlier *décharge* of Fermier Julien Berthe (1750-56).

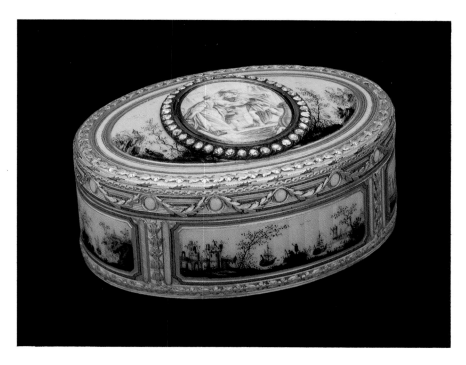

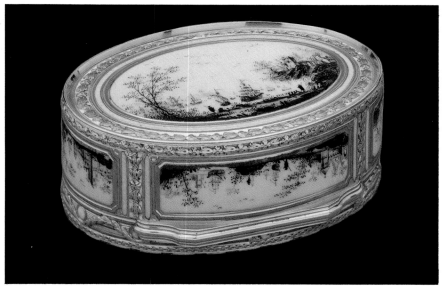

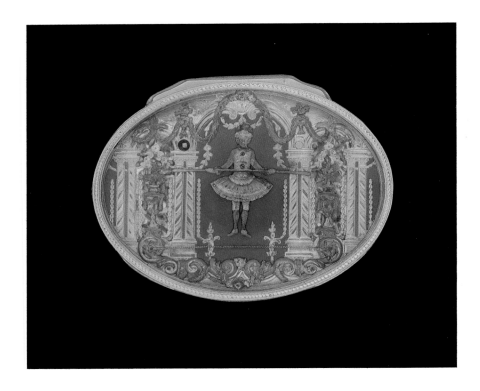

2

AN OVAL ENAMELLED FOUR-COLOUR GOLD AUTOMATON MUSICAL TABLE SNUFF-BOX with a full face tightrope-walking girl in billowing skirt holding a horizontal pole, on opaque pale blue enamel ground, flanked by chased gold double columns on either side and further decorated with suspended swags, two applied vases of flowers on marbled ground and scrolls beneath, under a glazed hinged cover, the vase with a musical trophy on matted ground in architectural setting, the sides pierced for sound and chased with four further musical trophies, with foliage and architectural borders. The tightrope walker dances, jumping into the air kicking one, then the other, and finally, both legs, the musical carillon playing on four bells.

7.7cm (3 in) long, Geneva, circa 1780, maker's mark crowned M&P in a shield.

Provenance: *The Henry Ford II Collection,* Sotheby's, New York, February 25, 1978, lot 4

Literature: Alfred Chapuis and Edouard Gelis, *Le Monde des Automates,* Paris, 1928, ill. 326

A group of four further Swiss boxes bearing the same unidentified maker's mark is in the Louvre (cf. S. Grandjean no. 602-606, marks illustrated on pp. 446/7 as not localised). Of these no. 605 (inv. no. OA2189) is closest in style and visibly by the same hand. (For a discussion of the problem of Swiss boxes and their hallmarks cf. no. 1 of this catalogue).

Automaton snuff-boxes of this period are usually associated with Geneva, centre for all automata in the late 18th and early 19th century. Rare cases of the use of Swiss mechanisms in contemporary French boxes are recorded (cf. no. 54 of the catalogue). A watch with a tightrope-walker from the Sandoz Collection is illustrated by Alfred Chapuis and Edmond Droz, *Les Automates,* 1949, fig. 197.

 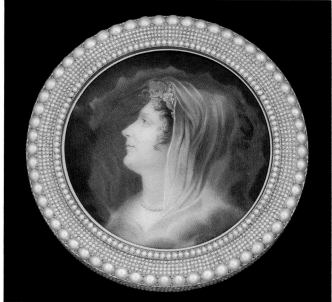

3

A CIRCULAR PEARL-SET GOLD BOITE-A-PORTRAIT, the cover set with an enamel miniature of Empress Joséphine, in profile facing left, wearing flowers in her hair, a necklace and a veil, on a cloudy background, the entire box set with countless seed-pearls, the base with a swirling rosette of pearls, with larger pearl borders.

7.7cm (3 in) diam., unmarked, circa 1810, probably Swiss.

Originally considered to be of English origin, this box is almost certainly Swiss. Although no similar boxes are known, the type of pearl decoration frequently occurs on Geneva-made watch-cases of this period.

The portrait of Empress Joséphine is based on a drawing at Malmaison by Isabey dated 1798 (cf. Mme de Basily-Callimaki, *J. B. Isabey,* 1909, p. 45). For a similar cameo-type miniature on a *boîte à parfum* and a pendant in the Louvre cf. S. Grandjean nos. 292 and 373, where two further "cameo" portraits signed Parant in the Louvre are mentioned (Inv. RF-179 and Inv. OA-5006).

4

A Circular Imperial Presentation Three-Colour Gold-Mounted Boite-a-Portrait, the hinged cover set with a glazed miniature on parchment, of Emperor Napoleon *signed Isabey 1812,* almost full face, wearing coronation robes, gold laurel crown and the *Ordre de la Légion d'Honneur,* the mat gold border chased with red and yellow gold stars and bees, the base with initial N on circular blue guilloché enamel panel with laurel-leaf crown, surrounded by radiating flutes chased with trophies of arms in three-colour gold, with outer laurel-leaf and ribbon frame, the sides with three bands of yellow gold scrolling foliage and red gold rosettes on matted ground flanked by frames *en suite.*

10.2cm (4 in) diam., maker Moulinié, Bautte et Moynier, Geneva, circa 1812, inscribed on flange *Moulinie, Bautte et Moynier à Genève, 18 kt.*

Provenance: Presented to Countess Marie Walewska by Napoleon
 Acquired in Sweden 1915, by Sven Axelson Johnson
 Bukovski, Stockholm, April 24, 1981, lot 1037

Exhibited: Bukovski, Stockholm 1915, *Utställning av Aldra Svenska
 Porträtt Miniatyrer*

Moulinié was active as from 1795, Moynier as from 1790, Moulinié Bautte & Co. from 1804 to 1808, the associates Moulinié, Bautte et Moynier from 1808 to 1821.

Traditionally this box was given by Napoleon to Marie Walewska (1789-1817), who became his mistress in 1807. Marie Walewska visited the Emperor one night during the retreat from Russia, 1812, and later on the Island of Elba, where the box was presumably given to her. In 1816 she married Maréchal d'Ornano. The box was brought to Sweden by a Polish nobleman, 1916.

Napoleon visited Geneva in 1798, in 1800 and 1802. This particular commission is obviously connected with the annexation of the Canton of Geneva in 1798. Until 1813 Geneva remained *Département du Léman* and accepted Napoleon's rule. The miniature by Isabey must have been painted either just before Napoleon's departure for the Russian Campaign or after his return on December 18, 1812. It is based on a *Médallion en habit da sacre à mi corps tourné à gauche* by Isabey engraved by A. Tardieu in 1805 (cf. Mme de Basily-Callimaki, *J. B. Isabey,* 1909, p. 426). A Sèvres porcelain plaque ordered from Isabey and executed in 1806 shows the Emperor enthroned in a very similar position. A similar miniature by Isabey dated 1810 and with Napoleon's head at a different angle is in the Wallace Collection (M 232, Graham Reynolds, *Wallace Collection Catalogue of Miniatures,* 1980, no. 184).

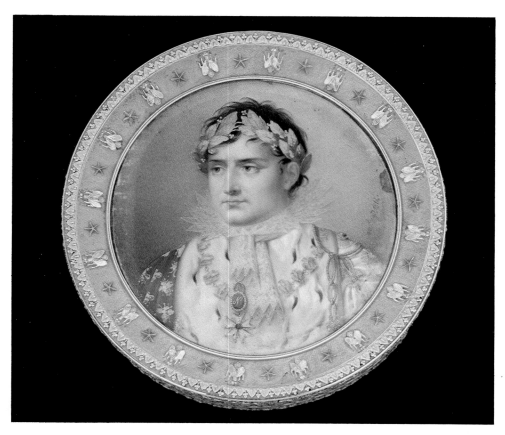

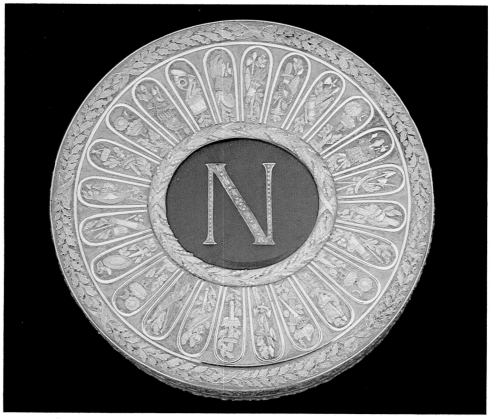

Italy

5

A RECTANGULAR GOLD-MOUNTED MOSAIC TABLE SNUFF-BOX with canted corners, the cover with a Roman micromosaic panel of a Polar bear and a hound fighting over an apple in a landscape with a single tree, all on pale-blue background, the base with a stag and a hind released from drawing a chariot, the sides with masks and scrolling acanthus foliage on similar ground, the mounts chased with scrolling acanthus foliage on matted ground.

8.7cm (3⅜ in) long, mark illegible, later French control marks, probably Italian, circa 1800.

Provenance: The late Martin Foster, Esq., Christie's, London, July 5, 1977, lot 211

Although unmarked, this box is stylistically close to objects made in Rome at the turn of the century. The mosaics are possibly by the hand of Livorio Salandri (for a box with a grey monochrome mosaic on blue ground, cf. D. Petochi, fig. 25).

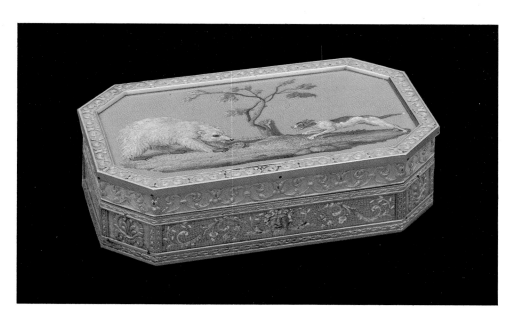

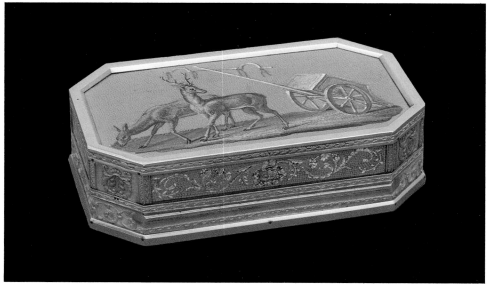

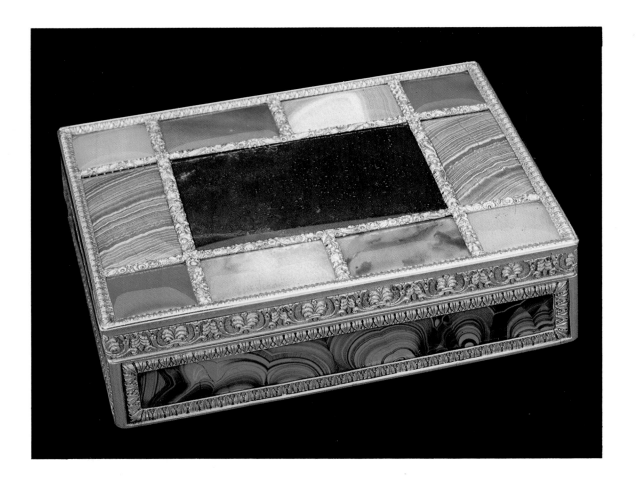

6

A RECTANGULAR GOLD-MOUNTED HARDSTONE BOX, the cover set with rectangular bloodstone, banded and foiled agate plaques, the sides in malachite, the base in lapis-lazuli and aventurine quartz with chased flower and foliage partitions, anthemion and stylized leaf borders, the interior with a miniature of Sir William Drummond, almost full face, wearing a fur-trimmed dark cloak and red shawl, inscribed "Right honorable Sir William Drummond 1828" and *Fratelli Mascelli a Roma*.

11.3cm (4½ in) long, maker G. A. Mascelli, Rome, circa 1828.

Giovanni Andrea Mascelli (1796-1870) was registered as goldsmith February 26, 1826. His address from 1826 to 1866 was at 90/1 Piazza di Spagna, where he worked together with his brother Giovacchino. Elected *Console* of the Goldsmiths' Guild. For his mark (GA74M in lozenge), cf. C. G. Bulgari, *Argentari, Gemmari e Orafi d'Italia,* Rome, vol 2, 1980, p. 108, no. 682.

Sir William Drummond (1770-1828) scholar, diplomat and M.P. was Envoy Extraordinary and Plenipotentiary to the Court of Naples in 1801 and 1806. Between 1803 and 1806 he acted as Ambassador to the Ottoman Porte. Nelson wrote of him in his dispatches January 16, 1804 (v. 374): "I do not know Mr Drummond. I am told, that he is not likely to make the Porte understand the intended purity of our cabinet".

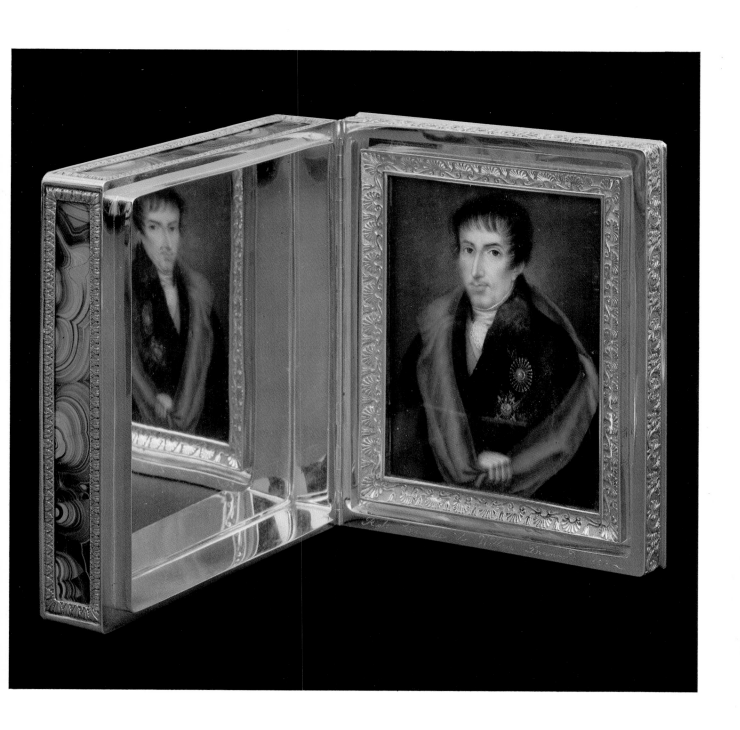

Austrian Empire

7

A Rectangular Two-Colour Gold-Mounted Mosaic Snuff-Box, the cover inset with a Roman micromosaic of dancing figures in Classical dress *in the manner of Claude Lorrain,* in a Roman Campagna landscape, the border chased with ovals containing leaves on matted ground, the base chased with a couple of dancing peasants on matted ground, flanked by engine-turned lozenges and with a border *en suite,* the sides with reeded engine-turned panels.

8.8cm (3⁷⁄₁₆ in) long, Prague, 1807, maker's mark PG in an escutcheon, also stamped B2.

This typical box of the Empire period could be attributed to any of the major European centres. The hallmarks however point to the Austrian Empire. Roman mosaics, much like Geneva enamels and German hardstones, were exported all over the world. The Gilbert Collection contains a number of such examples (cf. this catalogue nos. 5, 28, 59, 62).

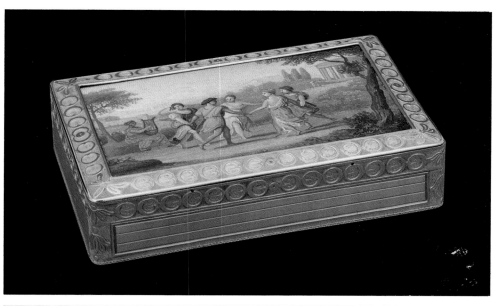

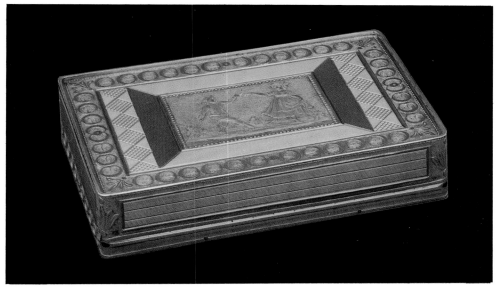

Russia

8

An Oval Vari-Coloured Gold-Mounted Steel Snuff-Box, the cover, base and sides inlaid in four-colour gold with farmyard scenes on an engraved lozenge-and-stripe ground within scroll borders divided by chased gold panels.

8.7cm (3⅜ in) long, attributed to F. J. Kolbe, St. Petersburg, circa 1760, unmarked.

Provenance: Christie's, Geneva, *Fine Objects of Vertu,* May 12, 1981, lot 441

A small number of boxes similar to the present example are recorded. A steel box chased and inlaid with putti signed *Kolbe à St. Petersburg* was sold by Sotheby's, Zurich, November 16, 1976, lot 225. A four-colour gold box with similar chasing in the Walters Gallery, Baltimore (cf. A. K. Snowman, pl. 654/5) is signed *F. J. Kolb à St. Petersbourg*. A Friedrich Joseph Kolbe of Würzburg arrived in St. Petersburg, 1793, was master goldsmith in 1806 and obtained the Imperial Warrant 1820/25. But both boxes mentioned above date from circa 1760. There may therefore have been another F. J. Kolbe active in Russia three decades earlier (or was it the same goldsmith on an earlier unrecorded stay? Was he related to the J. P. Kolbe working in Vienna in the seventies?). For signed boxes by J. P. Kolbe cf. S. Grandjean, *The Waddesdon Catalogue,* no. 55 and Christie's London, *Highly Important Gold Boxes, Property of Lord Rothschild,* June 30, 1982, lot 43.

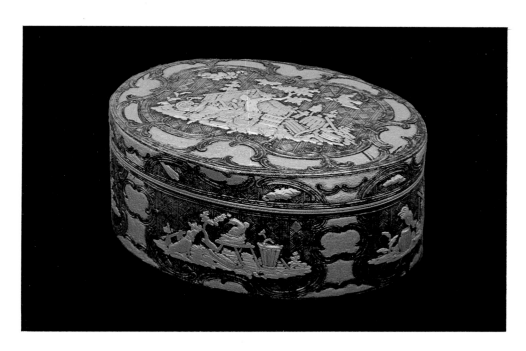

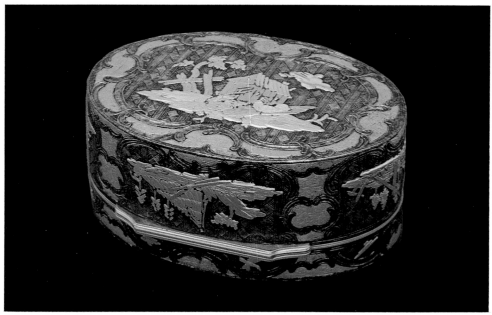

9

A Catherine the Great Russian Rectangular Gold and Enamel Box, all sides engraved with star-shaped motifs simulating embroidery and chased with entrelac and foliage borders, the cover enamelled with a badge of the Russian Order of St. Andrew suspended from a waved blue ribbon, the front enamelled with the Prussian Order of the Black Eagle suspended from an orange ribbon, the back with the Polish Order of the White Eagle suspended from a blue ribbon, the sides with the Orders of St. Anne and St. Alexander Nevsky suspended from red ribbons, the base enamelled with the coat-of-arms of the Korff family with helmet and drapery, surrounded by military trophies and surmounted by two mermaids holding a lily with three stars above

8cm (3⅛ in) long, unmarked, circa 1765, attributed to Jean-Pierre Ador, in original red morocco case gilt with a rococo cartouche and flower sprays.

Provenance: Baron Nicolaus Friedrich von Korff
 Baron Carl Gustav von Korff, his brother. Thence by descent
 Christie's, Geneva, *Important Gold Boxes,* May 10, 1983, lot 68

Typical for mid-18th Century Russian snuff-boxes, this box is unmarked. By comparison of technical and stylistic details, it can safely be attributed to Jean-Pierre Ador (cf. the chasing of the gold border on the snuff-box illustrated by A. K. Snowman, pls. 620, 625 and the soft enamel colours on the snuff-boxes illustrated in A. v. Solodkoff, *Russian Gold and Silver,* 1981, pls. 178, 179). Based on the biography of Baron Korff, this snuff-box can be dated between 1762 and 1766, that is the year he received the Order of St. Andrew and the year of his death.

Baron Nicolaus von Korff, 1710-1766, was one of the German Balts who made a career in Russia where he joined the army at the age of fourteen. In 1740 he married Catherine, the daughter of Count Carl Skavronski. She was the cousin of Grand Duchess Elizabeth, daughter of Peter the Great and his wife Catherine I, née Skavronska. With the accession to the throne of Elizabeth Petrovna on November 24th, 1741, Korff was promoted to the Imperial Guard and given a mission to accompany the designated heir to the Russian throne, Duke Carl Peter of Holstein, (later Tzar Peter III) from Kiel to St. Petersburg. In the following year he received the Order of St. Anne of Holstein.

In connection with the Treaty of Abo and a mission to Stockholm, Korff was decorated with the Order of St. Alexander Nevsky in 1744. As Russian Governor of parts of Prussia during the Seven Years War, with residence in Königsberg, he received in 1758, the Polish Order of the White Eagle. Promoted to the head of the Police of St. Petersburg in 1760, he was decorated with the Order of St. Andrew by Peter III on January 10, 1762.

The same year Frederick the Great awarded him the Prussian Order of the Black Eagle and Catherine the Great made him a member of the State Council. Korff died in St. Petersburg on April 24th, 1766.

Ador was born 1724 in Vuiteboeuf in Switzerland. He is recorded as working in Geneva from 1753 until 1759 when he apparently left Switzerland for Russia. In the early 1760s he settled in St. Petersburg. His earliest signed and dated work is the Orlov-Vase (Walters Art Gallery, Baltimore), a gold and enamel perfume vase dated 1768. Ador became one of the most important goldsmiths in Russia, mainly working for Catherine the Great and her court. He died 1784 in St. Petersburg.

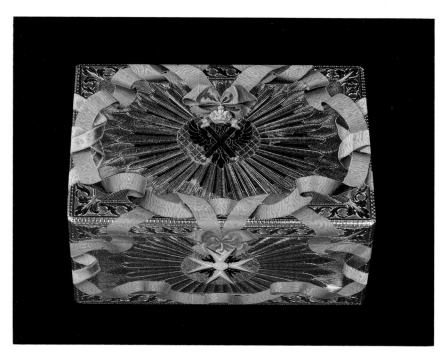

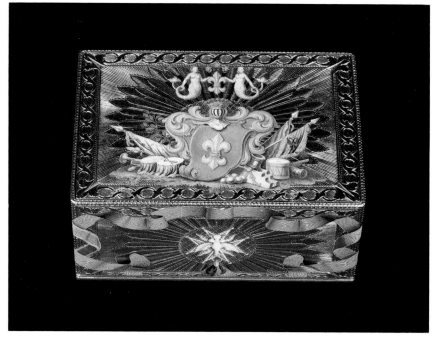

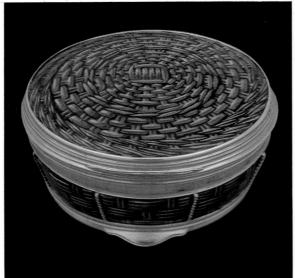

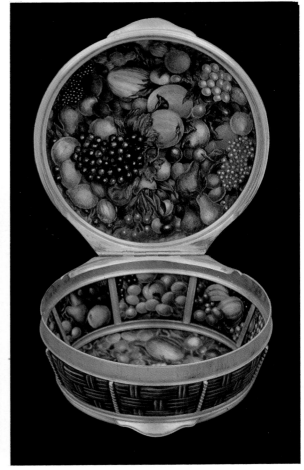

10

A Basket-Shaped Gold-Mounted Enamelled Gold Snuff-Box, the *à cage* panels painted in brown to simulate wickerwork, the interior entirely painted with fruit and vegetables, with plain burnished gold mounts and corded gold separations to the panels.

5.8cm (2¼ in) diam., probably St. Petersburg, circa 1770/80, unmarked, the enamels attributed to Charles-Jacques de Mailly.

A basket-shaped snuff-box, hallmarked in Russia, with similar still-life panels mounted *à cage,* signed *De Mailly invt. Pinxt,* presented by Catherine the Great to A. Narishkine in 1796 is in the Louvre (cf. S. Grandjean, no. 530).

Charles-Jacques de Mailly (1740?-1817), worked as an enamel painter in Paris and St. Petersburg. He exhibited at the Salon in 1771. In 1775 he painted the portrait of Pugatchov in Moscow. His portrait of Empress Catherine the Great probably dates from this period. Some flower paintings related to those on this box are recorded.

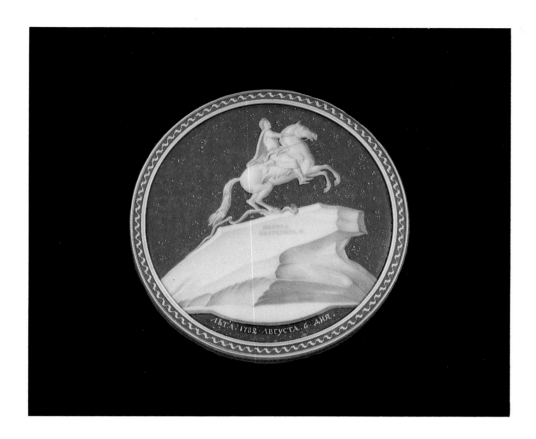

11

A Catherine the Great Circular Enamelled Gold Box, the cover painted *en grisaille* with the Monument of Peter the Great, the rock inscribed in gilt Cyrillic letters *To Peter I from Catherine II* on blue ground imitating lapis-lazuli, inscribed beneath in gilt Cyrillic letters *1782, August 6th;* the outer frame gilt with a foliage ribbon, the sides with opaque white enamel lines and gilt crosses, the base gilt with stylized foliage forming a rosette.

7.5cm (2⅞ in) diam., maker François-Xavier Bouddé, St. Petersburg, circa 1782.

Provenance: Graupe, Berlin, *Kostbarkeiten aus einer Fürstlichen Schatzkammer,* December 17, 1932, lot 42

Literature: A. von Solodkoff, *Russian Gold and Silver,* 1981, fig. 192 and no. 227 (for Bouddé's mark)

François-Xavier Bouddé, of French origin but born in Hamburg, became master goldsmith in St. Petersburg, January 10, 1769 and alderman in 1779-85. His engraved signature is *Bouddé à St. Petersbourg.* A number of snuff-boxes by Bouddé are in the Treasury of the Hermitage, Leningrad, another is in the Louvre.

This box commemorates the unveiling of the monument of Peter the Great on the Senate Square in St. Petersburg. It was commissioned by Catherine the Great from the French sculptor Maurice Etienne Falconet (1716-1791), who came to Russia 1766 and worked on the monument from 1768-1778. The bronze monument, its head modelled by Marie Anne Collot, stands on a block of Finnish granite. The unveiling, which took place on August 7th (?) 1782, was also commemorated by a medal by Johann Georg Waechter bearing the same date as the box.

England

12

A QUEEN ANNE HEAVY OVAL BURNISHED GOLD Box of shallow shape, the hinged cover inset with a glazed miniature of the Hay-Drummond family coat-of-arms, the interior to the cover with a miniature on ivory of Venus and two putti *after G. A. Pellegrini* under a hinged glazed partition.

8.3cm (3¼ in) long, circa 1710, unmarked.

Thomas (Hay), Earl of Kinnoull (circa 1660-1718/19), son of George Hay of Balhousie was M.P. (Tory) for Perth, 1693-7. He was created Viscount of Dupplin, 1697. He was married to Elizabeth, daughter of William (Drummond), 1st Viscount Strathallan in 1683. In 1715 he was imprisoned in Edinburgh Castle for his pro-Stuart activities.

The miniature of Venus and Cupid is based on a painting in an Italian private collection by Giovanni Antonio Pellegrini, exhibited Galleria Celestini, Milano (cf. Arte Illustrata, Oct./Nov./Dec. 1969). For a preparatory drawing cf. *Exhibition of Old Master Drawings,* Chaucer Fine Arts Inc., London, December 1982, no. 10.

This is a typical Queen Anne plain gold box of flat oval shape with pronounced hinge, of which similar examples are illustrated by A. K. Snowman, pl. 430 and Le Corbeiller, ill. 620/1. The coat-of-arms is probably by the hand of B. Lens (1682-1740) miniature painter to King George I and George II.

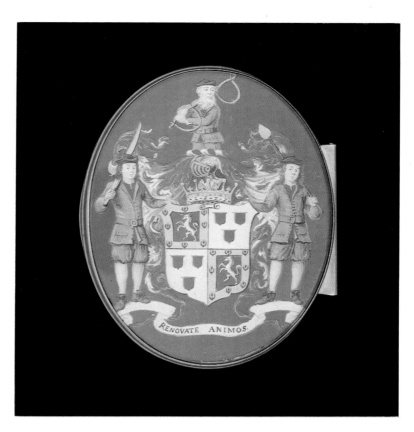

13

A SHAPED CIRCULAR ENAMELLED GOLD BOX combining a Blois watch-case enamelled with subjects from the Story of Theogenes and Chariclea and a George II mount chased with scrolls and enamelled with pink and blue flowers and green foliage, the cover painted *en plein* with Amphitrite carried by a Merman.

4.2cm (1¾ in) wide, the watch-case circa 1715, the mount, circa 1745, unmarked.

The subjects on this Blois watch-case are taken from the "Theogenes and Chariclea" by Heliodorus (trans. into French by J. de Montlyard in 1623) and based on a series of paintings by Gerrit van Honthorst at Kronborg Castle in Denmark (cf. Photothèque du Louvre, Decimal Index of Art of the Netherlands, nos. 17.428, 17.430, 17.431). Base: The Sacrifice of Theogenes and Chariclea before the King and Queen of Ethiopia; Sides: Chariclea and the wounded Theogenes; Chariclea showing her scarf; the first meeting of Theogenes and Chariclea. The enamel on the cover is based on an engraving by L. Surugue after Charles Coypel

An unusual but not unique combination of two elements dating from different epochs. The mount of this box, though French in style, is probably English.

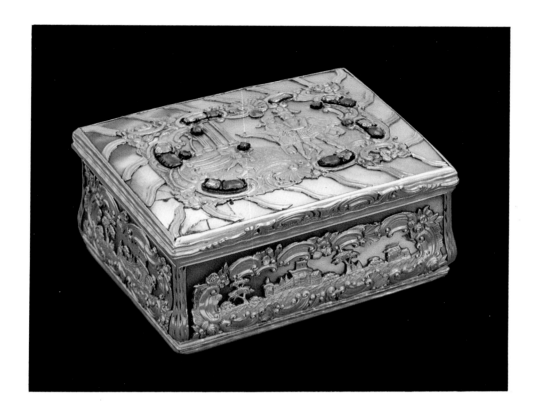

14

A GEORGE II GEM-SET MOTHER-OF-PEARL AND GOLD SNUFF-BOX, the cover applied in gold with a warrior and a lady approaching the Temple of Love, the scene surrounded by rubies and diamonds set in raised mounts and with waved flutes, the sides and base similarly decorated with castles, architecture and landscapes in scroll surrounds, waved mounts and corners and scroll thumbpiece.

7.3cm (2⅞ in) long, unmarked, mid-18th Century.

Provenance: Christie's, London, May 26, 1964, lot 112 (colour frontispiece)

Literature: Le Corbeiller, pl. IIb (colour illustration)

This type of box was mainly produced in Germany. Style and jewels however, point to an English origin.

15

A George II Rectangular Gem-Set and Enamelled Gold Snuff-Box, the cover enamelled with red and white castles, a lake with ducks, a shepherd, three gold cows, green trees and shrubs in the background within a waved and stepped border, all on *sablé* ground, the burnished base with an architectural motif and trees on matted ground in a scroll cartouche, the sides chased with scallop shells and acanthus leaves at the corners, the foliate thumbpiece set with a cushion-shaped and a circular-cut diamond flanked by rose-cut diamonds in scroll-shaped mounts.

8.5cm (3¼ in) long, unmarked, mid-18th Century, with later Austrian control mark.

No comparable example to this box would seem to exist. A possible Dutch or German origin should not be excluded.

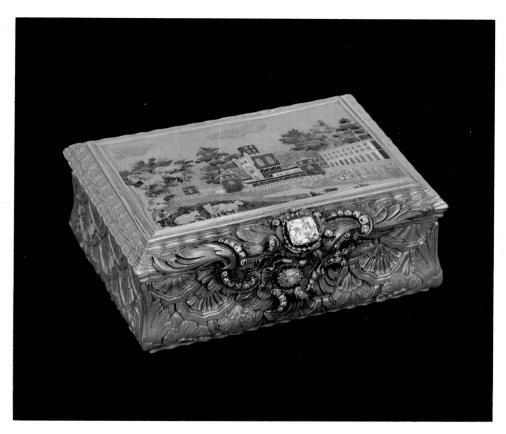

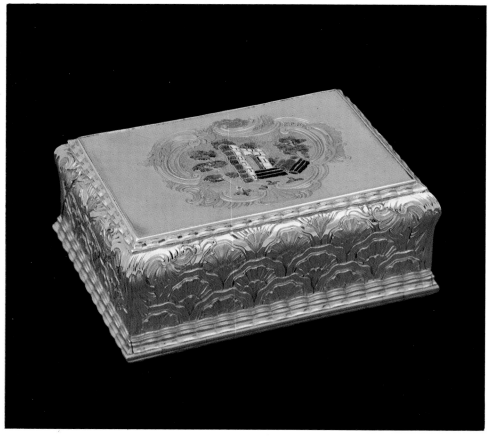

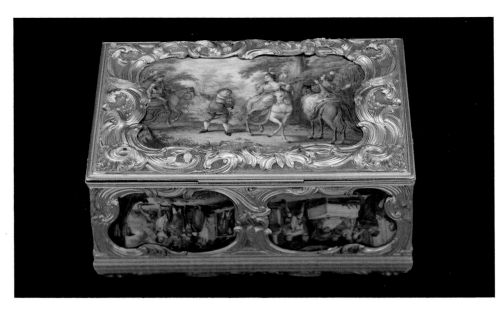

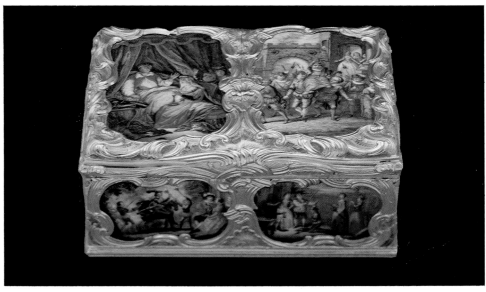

16

A George II Rectangular Enamelled Gold Triple-Opening Box painted *en plein* with nine scenes from the life of Don Quichotte in shaped rococo mounts chased in gold with scrolls, shells and foliage, the double cover opening to reveal two compartments, the base containing a watch, the movement *signed Dan. De St. Leu, London, 564,* set in a gold panel chased with scrolls and emblems of the Sciences, its white enamel dial with Roman numerals, alternating with emeralds, the bezel set with rubies.

8.6cm (3⅜ in) long, circa 1750-60, the enamels attributed to George Michael Moser.

Provenance: Traditionally given by Louis XV to M. de Vougelot, French
 Ambassador to the Court in London
 Viscount Bearsted, M.C.

Literature: R. and M. Norton, pp. 82-3, pl. 27 and 28A

Exhibited: *International Art Treasures Exhibition,* Victoria and Albert
 Museum, London, 1962, no. 350
 British Antique Dealer's Association Golden Jubilee Exhibition,
 Victoria and Albert Museum, London, 1968, no. 22 (ill. pl. 38
 and 39)

One of the major examples of an English enamelled gold mid-18th century box, its lavish decoration can be attributed to G. M. Moser.

George Michael Moser (1706-1783) studied as an enameller in Geneva and came to London in 1720. He was renowned for his chased gold boxes (cf. A. K. Snowman, ill. 445-8) and as a painter of enamels. His polychrome enamels are rare. For similarly painted watch-cases signed G. M. Moser, cf. C. Clutton and G. Daniels, *Watches,* 1965, ill. 276-8, Uto Auktionen, Zurich, October 17, 1977, lot 122 and Schweizerisches Landesmuseum, Zürich, *80. Jahresbericht,* 1971, pp. 23-24 and colour frontispiece (Inv. no. LM 49072). Moser was one of the founding members of the Incorporated Society of Artists and of the Royal Academy.

Daniel de St. Leu (1753-97) specialized in watches for the Near Eastern Market. For a typical triple-cased vari-colour gold clock, cf. Christie's Geneva, *Fine Clocks and Watches,* April 26, 1976, lot 206; for another, elaborately set with gems, cf. Christie's New York, March 8, 1978. He was also active for the Spanish Court.

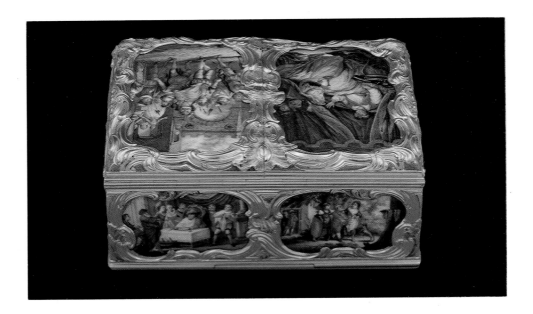

The subjects of this box are based on engravings after Ch. Coypel, published as "*Les Principales Aventures de l'Admirable Don Quichotte*", ed. Pierre de Hondt, 1746.

1. Cover (left): *Dame Rodrigue s'entretenant de nuit avec Don Quichotte est surprise par les Demoiselles de la Duchesse* (Pl. XXVII), engraved by B. Picart. The final oil version is in the Compiègne Museum (Inv. 3583, no. 141)

 Cover (right): *Entrée de Sancho dans l'Isle de Barataria* (Pl. XXIV), engraved by P. Tanjé. Coypel's oil painting dated 1717 is in Compiègne (Inv. 3578, no. 1401)

2. Base: *Don Quichotte fait demander par Sancho ala Duchesse la permission de la voir* (Pl. XV), engraved by J. v. Schley, 1742. The final oil version is in Compiègne (LP 4877, Inv. 3570)

3. (front): not identified and not included in the *Recueil*.

 (back): *La Table de Sancho Gouverneur est servie magnifiquement mais sitost qu'il veut manger, le Medecin Pedro Rezzio fait enlever les plats* (Pl. XXVI), engraved by J. v. Schley.

 (left): *Don Quichotte et Sancho montes sur un Cheval de Bois s'imaginent traverser les Airs pour aller vanger Doloride* (Pl. XXII), engraved by B. Picart.

 (right): *Don Quichotte croit recevoir dans l'Hottellerie l'Ordre de Chevalier* (Pl. II), engraved by B. Picart. The final oil version is in Compiègne (LP 4873, Inv. 3555)

Coypel was also responsible for the cartoons of a series of tapestries woven 1714-1781 at the Manufacture of the Gobelins by Jans and Le Febvre with closely related compositions and colours to the present box (Musée du Louvre, Paris).

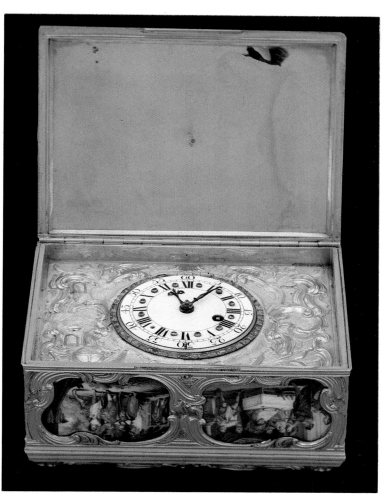

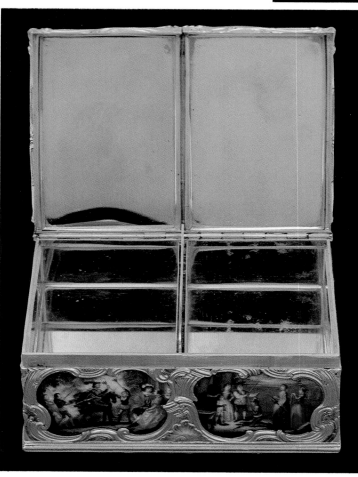

17

A George II Gold-Mounted Agate Combined Table Snuff-Box and Snuff-Bottle shaped as a huntsman and his dog, the man reclining, wearing a three-cornered hat, vest, breeches and boots, with rose-diamond eyes and buttons, the seated hound with similar eyes and detachable head and gold collar inscribed on white enamel *Fidèle et Sincère,* the cover applied in gold with a huntsman blowing a horn standing astride a killed stag in a wooded landscape, surrounded by rococo scrolls and flanked on the left by a vase of flowers, the scroll thumbpiece set with rose-diamonds.

9cm (3¾ in) high, unmarked, circa 1760, later control marks.

Provenance: Enrico Caruso, Parke-Bernet 1949
 Christie's, London, 18 December 1973, lot 193
 Christie, Geneva, *Highly Important Gold Boxes,* 8 May 1979, lot 118

This *Jagdtabatiere* or *Tabatière da chasse* belongs to a small group of similar combined snuff-boxes/snuff-bottles of which an example with a female hunter was sold by Christie's Geneva, April 26, 1978, lot 340. Another, to which the present item could be a companion, is in the Museo Lazaro Galdiano, Madrid (cf. A. K. Snowman, pl. 455). Yet another, also probably by the same hand, is in the Victoria and Albert Museum, London (cf. Howard Ricketts, col. ill. p. 26).

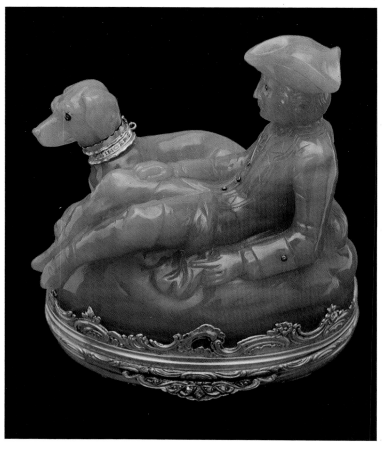

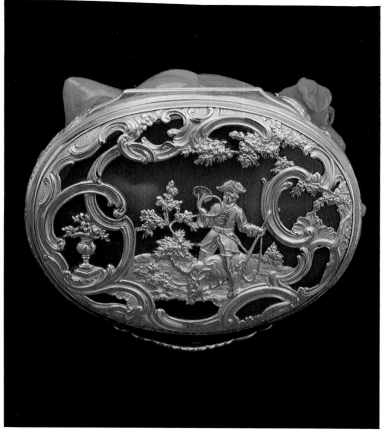

18

A GEORGE II ENAMEL AND TWO-COLOUR GOLD CHINOISERIE TABLE SNUFF-BOX, each panel enamelled in translucent royal blue over a radiating sunray pattern, the cover applied with a chased and pierced gold decoration of architecture, trees and two Chinamen within a scroll framework, the sides and base with flowers and scrolls, the burnished gold mount with interweaving ribbons and anthemion.

8.5cm (3¼ in) long, circa 1760, unmarked, with later control marks.

Provenance: Christie's, Geneva, *Fine Objects of Vertu,* May 13, 1980, lot 486

For another Chinoiserie snuff-box with similar chased gold decoration cf. A. K. Snowman, pl. 453. Chinese influence was strongly felt throughout Europe between 1735 and 1760. Chinoiserie boxes, popular mainly in France, Germany and England during the reigns of Louis XV and George II exist in many materials including mother-of-pearl, enamels and gold.

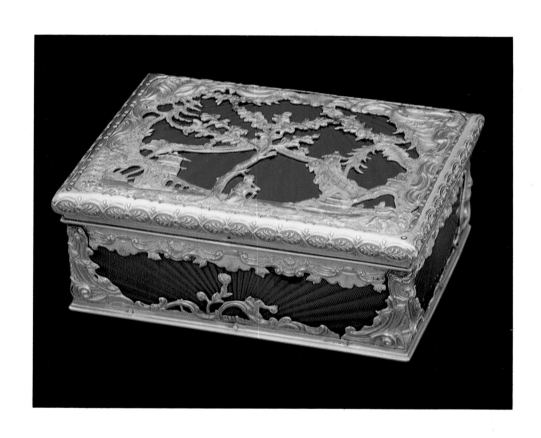

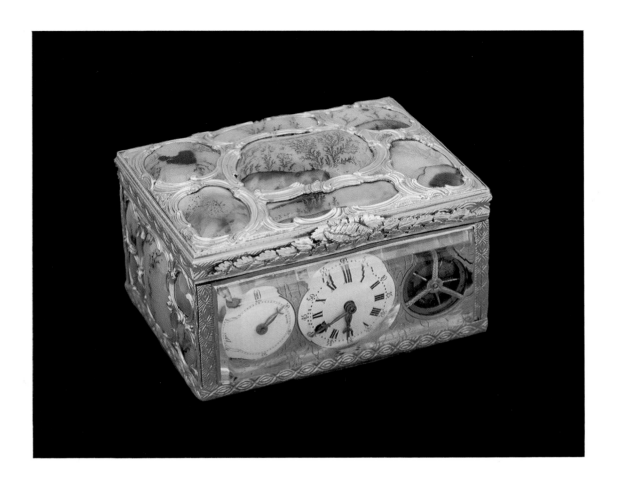

19

A GEORGE III RECTANGULAR GOLD-MOUNTED AGATE TABLE SNUFF-BOX, the cover set with nine shaped moss-agate panels in chased gold scroll mounts, the front with a glazed panel showing the white enamel watch-dial with Roman numerals flanked by the regulator and open balance, the rear opening to reveal a painting in oils with a landscape and two automata revolving panels showing a man on a donkey, a lady in an interior, a bird in a tree, a pigeon and a hen with interweaving ribbon borders and two-colour gold shell and foliage thumbpiece.

7.8cm (3 in) long, by James Cox, circa 1770, unmarked.

Provenance: Sotheby's, London, May 17, 1956, lot 95

Literature: Berry Hill, p. 112 (ill. 89 and 90)
 Le Corbeiller no. 287

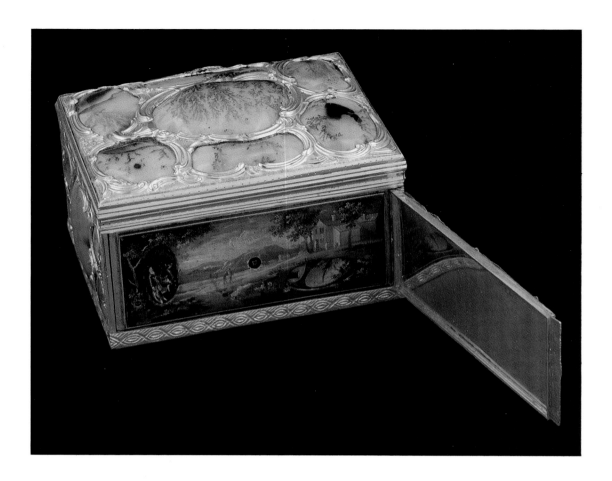

For an almost identical box, the watch dial signed by James Cox, with a very similar landscape but with erotic automata, cf. Christie's Geneva, *Fine Objects of Vertu,* May 12, 1981, lot 444. For another from the Henry Ford II Collection, cf. Sotheby Parke Bernet, New York, February 25, 1978, lot 11.

James Cox, goldsmith and jeweller of 103 Shoe Lane near Fleet Street, was a skilful maker of chiming clocks and watches as well as of various kinds of musical automata. These chiming and musical products of his ingenuity were in considerable demand by officials in China where they were known as 'sing songs', Probably the most celebrated of all Cox's automata was the Peacock Clock which was commissioned by Prince Potemkine for his Tauride Palace, transferred to the Winter Palace by Paul I. His mechanisms were mainly supplied by Jacquet-Droz and Leschot of Geneva or by their London partner Maillardet (cf. Marjory Sykes, *Fantasy in movement. The amazing 'toys'—clocks, watches and automata—of James Cox,* in 'Art & Antiques', February 25, 1978, pp. 20-1).

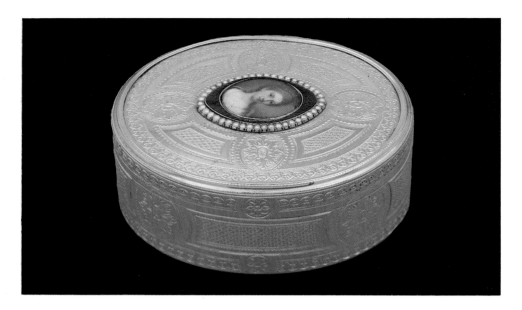

20

A GEORGE III OVAL ENGINE-TURNED GOLD SNUFF-BOX, the cover inset with an enamel miniature of a lady *by Nathaniel Hone, signed with initials and dated 1771,* almost full face, with upswept hair, white dress and blue cloak in an oval blue guilloché enamel panel with split-pearl border, the cover, sides and base decorated with circles, segments of circles, rosettes and stylised foliage borders.

8cm (3⅛ in) diam., maker's mark I.B., London, 1776.

Provenance: Sotheby's Monaco, November 29, 1975, lot 127

Nathaniel Hone (1718-1784) settled in London about 1742. He was one of the founding members of the Royal Academy where he exhibited from 1769 onwards. He was a painter of portraits and genre subjects in oils and of a large number of miniatures on ivory and enamel.

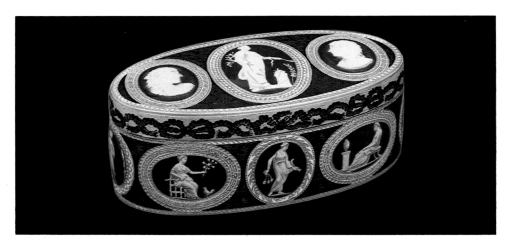

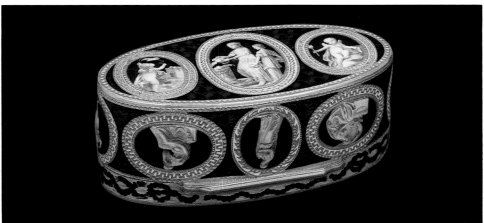

21

A GEORGE III OVAL ENAMELLED GOLD SNUFF-BOX, the cover with three oval Wedgwood plaques, a male and female profile flanking a classical female figure sacrificing at an altar, all in white on chocolate-brown ground, the base painted *en suite* in *camaieu brun* with three scenes allegorical of Love, the sides with eight medallions in Pompeian style and *basse taille* enamel interweaving ribbons above, all medallions with a turquoise border gilt with interlacing ribbons, all set in panels of royal blue guilloché enamel.

8cm (3⅛ in) long, maker's mark SG a dot between struck twice on the flange, probably for Sebastian Guerint, circa 1780.

Sebastian Guerint entered a first mark September 27, 1776 with address at 19 Beak Street, St. James's and two further marks in 1785 and 1799.

The enamels on this box are in the style of James Morriset and his pupil Augustin Toussaint (cf. Claude Blair, *Three Presentation Swords in the Victoria and Albert Museum,* London 1972). For a chatelaine with similar *grisaille* subjects on chocolate ground cf. Christie's, Geneva, *Fine Watches and Clocks,* November 29, 1982, lot 192.

22

A GEORGE III NAVETTE-SHAPED GEMSET AND ENAMELLED GOLD PATCH-BOX, the cover applied with crowned initial O flanked by palm-leaves in an oval frame, all set with rose-diamonds, the cover and base in blue translucent enamel over wave-and-pellet ground, the base set with an oval medallion of plaited hair, each within frames of white opaque enamel gilt with flowers alternating with blue guilloché enamel bands, the sides in blue guilloché enamel, gold scrolling foliage, white pellets and bands, rose-cut diamond pushpiece, the interior to the cover with a mirror, the interior to the base with a coat-of-arms and motto *Mihi cura futuri,* the flange inscribed 'The Right Honble Robert Henley Lord Ongley, Ob. Oct. 23, 1785 a 64'.

9.5cm (3⅞ in) long, circa 1785, unmarked.

Robert Henley-Ongley (circa 1720-1785) M.P. (Whig) for Bedford 1754-61 and for Beds. 1761-80 and 1784-85, created Baron Ongley of Old Warden 1776 in Ireland. A contemporary source says of him 'Mr Ongley is of a considerable fortune and family, and of a very fair character. Has given to the Government during the late troublesome times the most constant, cordial and disinterested support' (cf. H. A. Doubleday a.o., *The Complete Peerage,* 1945, vol. X, p. 65).

23

A George II Navette-Shaped Gemset and Enamelled Gold Patch-Box, the cover with monogram EGHC set with rose-diamonds on a purple guilloché enamel panel studded with pellets with a rose-diamond border, the base of similar colour studded in a border of gold pellets on white enamel, the sides with two lines of raised gold pellets, the interior to the cover with a mirror.

8.2 (3¼ in) long, unmarked, circa 1800

24

A GEORGE III OVAL ENAMELLED GOLD COMBINED WATCH AND SNUFF-BOX,
the cover inset with a white enamel dial with Roman numerals, hour,
minute and second-hands, the movement *signed Anth. Mesure London 1070,*
the bezel set with split-pearls within a panel of royal blue guilloché enamel
bordered by another split-pearl band, the base with a rosette on a blue
guilloché enamel panel of radiating flutes, the sides and base with borders of
interweaving green foliage, gilt ribbons and gilt and red roses, with original
enamelled gold key.

8.3cm (3½ in) long, London, 1800, 18kt.

Anthony Mesure (Measure), London 1799-1851, chronometer maker. His
addresses were 8 Craven Buildings, Drury Lane (1810) and 420 Strand
(1814-23). A signed pocket chronometer by Mesure is in the Ilbert
Collection, British Museum.

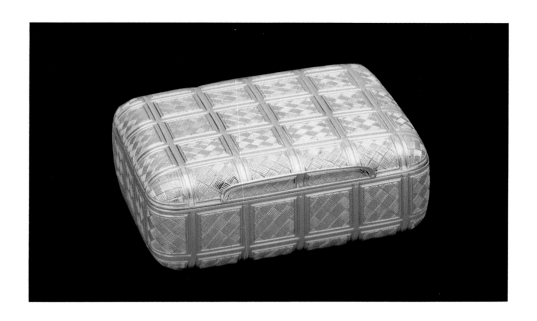

25

A GEORGE III BASKET-SHAPED GOLD SNUFF-BOX naturalistically chased to simulate wickerwork

6.7cm (2¾ in) long, unmarked, circa 1800.

For a very similar box dated 1798 cf. M. and R. Norton, ill. 287. Boxes shaped as naturalistically chased baskets were popular throughout Europe (for a Swedish box made in Stockholm, 1764, cf. A. K. Snowman, pl. 663).

26

A GEORGE III RECTANGULAR TWO-COLOUR GOLD TABLE SNUFF-BOX with rounded corners, applied on all sides with silver-gilt medallions in high relief depicting Paris and the Three Graces (cover) and Deities of the Olympus, each encased in a laurel-leaf frame, surrounded by pierced and chased scrolling acanthus foliage on matted ground and outer laurel-leaf borders.

10.2cm. (4 in) long, maker A. J. Strachan, London, 1806.

Provenance: Sotheby's, London, December 18, 1957, lot 138
 Neville Hamwee, Esq., Jersey

Literature: A. K. Snowman, pl. 474

Alexander James Strachan (†between 1842 and 1856) entered his first mark as a small-worker September 21, 1799, with address in Long Acre. He moved to 7 Mercer Street, Long Acre in 1803 and to 125 Long Acre in 1829. A second mark is recorded 6 August 1823. he was principal supplier of Rundell, Bridge and Rundell for royal presentation purposes and official occasions. Some of his finest pieces are in the Wellington Collection at Apsley House.

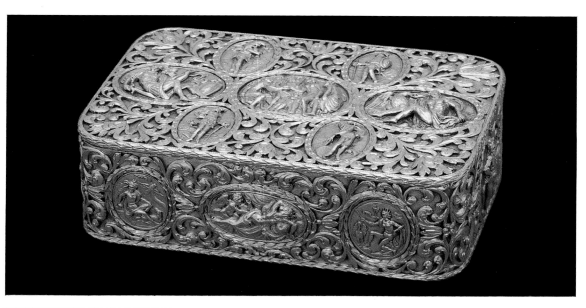

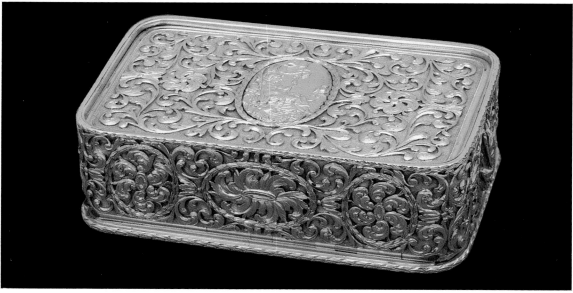

27

A GEORGE III SCALLOP-SHAPED GOLD BOX, the cover set with an enamel miniature of Voltaire three-quarters left, wearing a grey wig, red turban, purple scarf and green robe, the frame as a serpent biting its tail, the cover and base of the box naturalistically chased as the shell, the interior to the cover with an applied matted gold heart pierced by an arrow and a cryptic inscription *Dmbsb't 1807*

6.4cm (2½ in) long, maker's mark P.D. a dot between, possibly for Peter Delaunay, London, 1807.

Provenance: Christie's, Geneva, *Fine Objects of Vertu,* November 19, 1979, lot 90

Voltaire wrote to Mme du Deffond concerning his various portraits by J. Huber (1721-1786): *Monsieur Huber peindra au pastel, à l'huile, il vous dessinera sur une carte avec des ciseaux. Le tout en caricature; c'est ainsi qu'il m'a rendu ridicule d'un bout de l'Europe à l'autre.* (cf. S. Honegger, *Un peintre Genevois Jean Huber,* Geneva, 1933). Most of Huber's paintings were dispersed, some sent to Catherine the Great, others destroyed by fire. A number were, however, engraved on a plate by Huber titled *"Differents airs en trente têtes de Monsieur de Voltaire"* of which our portrait is the seventeenth. The original for this particular portrait is lost.

Enigmatic in shape, iconography and inscription, this box was obviously a very personal commission by an admirer of the philosopher. The serpent biting its tail entwined around Voltaire's portrait is a symbol of eternity as mentioned by the author himself in his *La bible enfin expliquée (le livre des nombres).*

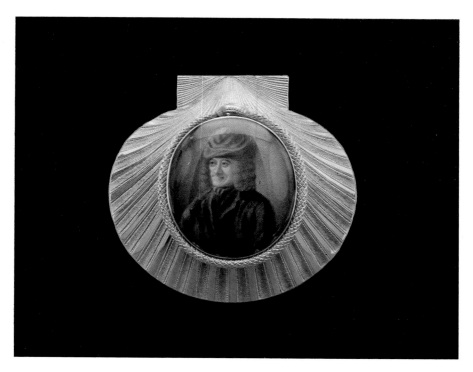

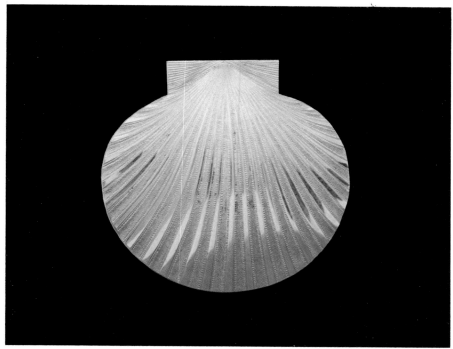

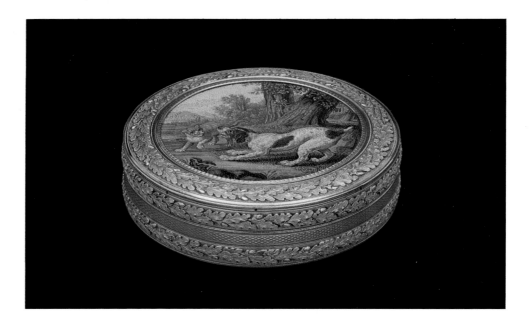

28

A GEORGE III CIRCULAR GOLD AND MOSAIC BOX, the cover inset with a Roman micromosaic of a fighting hound and a cat in a wooded landscape *signed Gioacchino Barbieri,* the border chased with an oak leaf and acorn wreath on matted ground, the sides and base with engine-turned panels and similar borders, the interior to the cover inscribed 'The Gift/of/the Most Noble/The Marquis of Hastings/Kg. etc. etc. etc. etc. etc. to/John Macwhirter, M.D./1817 A.D.'

7.6cm (3 in) diam., maker A. J. Strachan, London, 1807, 18kt.

Provenance: Christie's, London, June 24, 1970, lot 130 sold by a direct descendant of the original recipient, the great great-grandfather of the owner

For the maker A. J. Strachan cf. no. 26 of this catalogue

Gioacchino Barbieri (1783-1857), considered one of the first and foremost producers of micromosaic, invented black enamel mosaic. His workshop was at 99 Piazza di Spagna.

For a rectangular box with an almost identical mosaic attributed to F. Pūglieschi (cf. A. Gonzales-Palacios, no. 40). Another similar, on a box by P. A. Montauban, is in the Louvre (cf. S. Grandjean, no. 331, where further examples are mentioned). All these boxes illustrate the widespread distribution of Roman micromosaics throughout Europe.

Francis (Rawdon-Hastings) (1754-1826), Earl of Moira (1793), was married in 1804 to Flora, Countess of Loudon. In 1817 he was created Viscount Loudon, Earl of Rawdon and Marquess of Hastings. He fought in the American Wars of Independence and the Napoleonic Wars. In 1812 he attempted to form a Ministry with Wellesley. He was Governor General and Commander-in-Chief of the Forces of India 1813-22. Contemporary sources describe him as 'a tall athletic man with a stately figure and impressive manner. As a politician he is chiefly remembered as the friend and confidant of the Prince of Wales. His capacity for rule was remarkable, and as a skilful soldier and an admirable administrator he is not likely to be forgotten'. The Gilbert Collection also contains a miniature by H. Bone of the Marquis of Hastings (Misc. 88).

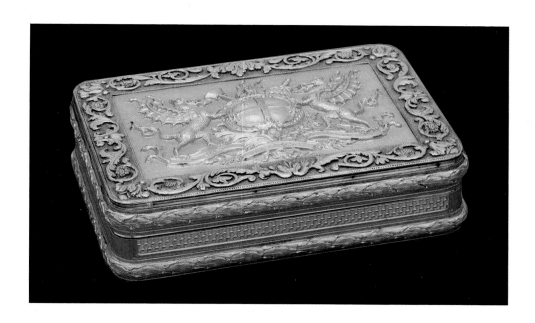

29

A GEORGE III RECTANGULAR TWO-COLOUR GOLD FREEDOM BOX, the cover embossed and chased with the arms of the City of London on matted ground, the surrounding border chased with scrolling acanthus foliage on mat ochre-coloured gold ground, the sides and base engine-turned with waved panels bordered by laurel-wreath frames, the interior to the cover inscribed 'Gwillin Lloyd Wardle'.

9cm (3½ in) long, maker A. J. Strachan, London, 1808.

For the maker cf. no. 26 of this catalogue.

Another Freedom of the City of London box by Strachan dated 1820 was sold by Christie's, London, December 18, 1974, lot 109.

Gwillin Lloyd Wardle (?1762-1833) a Lieutenant-Colonel in the Irish Yeomanry, was a Member of Parliament for Oakhampton from 1807 until 1812. He attacked Lord Castlereagh for the open sale of government places and also brought charges against Frederick, Duke of York, the Commander-in-Chief, for selling Army Commissions through his mistress Anne Clark. As a result, a parliamentary committee forced the Duke to resign in 1809. In recognition, the Corporation of London voted Wardle the Freedom on April 6, 1809 and made a payment of £105 to Messrs Coward and Smith for the gold box. Wardle was then sued by tradesmen for the cost of furnishing a house for Mrs. Clark, whereupon an attempt was made to rescind the Freedom at a special meeting of the Court of Common Council on August 1, 1809. This attempt failed and the Freedom was confirmed and the address published. The earlier date of this box shows that Strachan had a number of Freedom boxes in stock.

30

A George III Rectangular Three-Colour Gold Table Snuff-Box with convex sides, chased with scrolling acanthus foliage and flowers in yellow and red gold on matted ground, the interior to the cover set with a miniature of Lavinia, Countess Spencer, *by Henry Bone,* full face wearing a turban, shirt with lace collar, green bodice, red cloak, inscribed on the reverse 'Rt. Honble./Countess Spencer/London Apl. 1817, Painted by Henry Bone/ R.A. Enamel painter/Ordinary to His Majesty/and Enamel painter/to His R.H. the Prince/Regent after a/Miniature by Hayton'. The interior to the base engraved 'Lavinia Countess Spencer/painted by Henry Bone/in 1817'.

9.4cm. (3⅞ in) long, circa 1817, unmarked.

Provenance: The Spencer Family Collection

Henry Bone (1755–1834) settled in London 1778, painted miniatures on ivory but is best known for his enamels mostly after old masters. He was painter to King George III, George IV and William IV, was appointed A.R.A. in 1801 and R.A. 1811 and was considered one of the best English miniature painters of his period.

Lavinia, 1st daughter of Charles Bingham, 1st Earl of Lucan (1762–1831), married 1781 (by special licence) George John, Earl Spencer (1758–1834). She was considered a woman of great beauty and intelligence, brilliance of conversation and charm of character, but other sources mention her 'coarseness of mind, as well as of expression, intolerance, the most extravagant abuse, the most unsparing scrunity . . . Political Asperity . . . exterminating Virtue and stern Piety (Lady Granville, *Memoirs,* vol. II, p. 352). By 1816 she is described as 'she is becoming very large in her person and uses a stick while walking' (The Farington Diary, vol. 1, p. 60, vol. VIII, p. 98.)

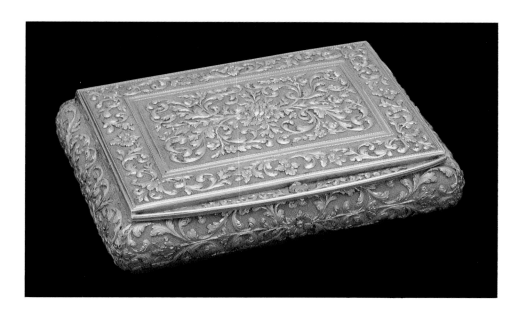

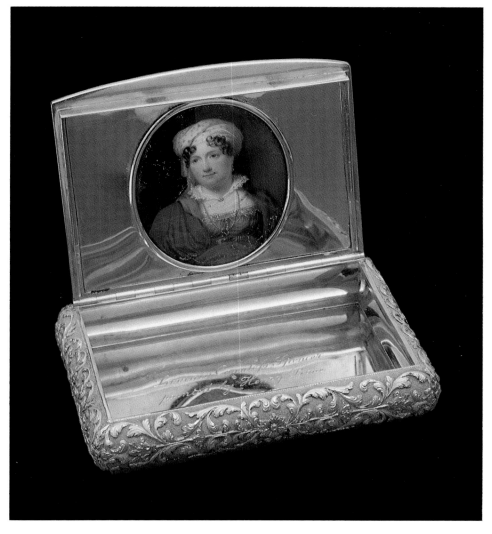

31

A George III Rectangular Gold Tabatiere-a-Portrait, the glazed cover set with two oval miniatures of Turenne and the Prince de Condé, the former three-quarters right, with dark wig, in armour, with white jabot and the sash of the Ordre du St. Esprit, the latter three-quarters left with grey wig, similarly dressed, in a panel chased with trophies of arms and scrolling acanthus foliage on matted ground, with outer opaque blue enamel border, the base with a large central rosette surrounded by acanthus foliage, the sides *en suite*.

9.1cm (3½ in) long, maker's mark IN, probably for John Northam, London, 1817.

Provenance: Christie's, London, May 26, 1964, lot 64
The late Earl of Sefton, Christie's, London, November 13, 1973, lot 176

John Northam, goldworker, entered his first mark in 1793 at 12 St. Martin's Street. He entered another mark on moving to Frith Street in 1796.

High quality gold boxes with comparable gold chasing and bearing the same maker's mark are illustrated by A. K. Snowman, pl. 487 and 486/8.

The miniatures are attributed to Louis Goullon (†1680) who worked mainly at the Danish Court but who was active in Paris 1672 to 1674.

The two miniatures are based on engravings by Robert Nanteuil (1623-1678). The portrait of Condé was engraved in 1662, that of Turenne in 1665 after a pastel by Nanteuil in the Louvre (Inv. 31.368). A very similar miniature of Turenne, his head facing left, is in the Louvre (RF 208).

Louis II, Prince de Condé (Le Grand Condé), Duc d'Enghien (1621-1686) and Henri de la Tour d'Auvergne, Vicomte de Turenne (1611-1675) were two of the greatest men of war of the 17th century. They fought on different fronts but joined forces for the battles of Freiburg i.Br. (1644) and Nördlingen (1645). During the Wars of the Fronde, Condé and Turenne fought each other, the first backed by Mademoiselle, daughter of Gaston d'Orléans, the second defending the interests of the young King.

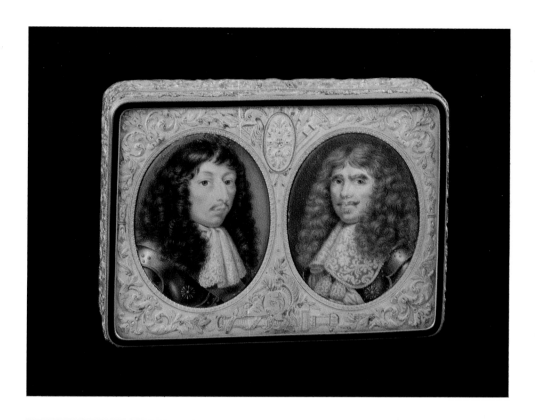

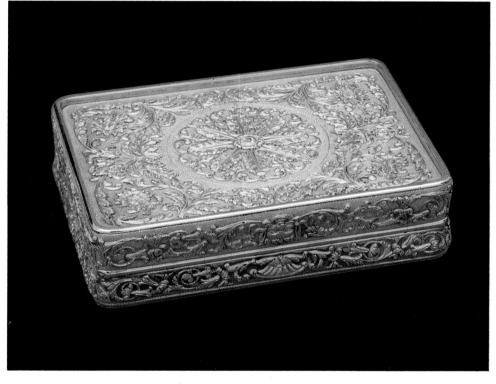

32

A George III Circular Two-Colour Gold Box the hinged cover inset with the three ivory profile portraits of Voltaire, Diderot and d'Alembert on black felt background under glass, the base with a central foliate rosette, the cover, base and sides chased with bands of acanthus foliage, oak-leaf and acorns, repectively in yellow and green gold.

9.3cm (3¾ in) diam., maker A. J. Strachan, London, 1818, 18kt.

Provenance: Christie's, Geneva, *Fine Objects of Vertu,* May 14, 1980, lot 498

For the maker cf. note for no. 26.

François Marie Arouet de Voltaire, French author and philosopher (1694-1778) wrote the *Henriade* (1728), *Candide* (1759) and the *Dictionnaire Philosophique* (1764), Denis Diderot (1713-1784), French author in charge of the production of the *Encyclopédie* and Jean Le Rond D'Alembert, French mathematician and philosopher (1717-1783) are here represented together as the three best-known *Encyclopédistes.*

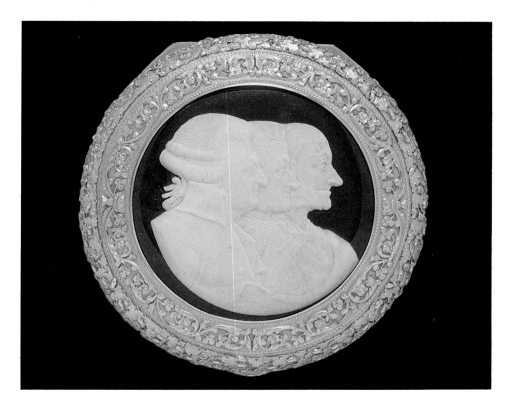

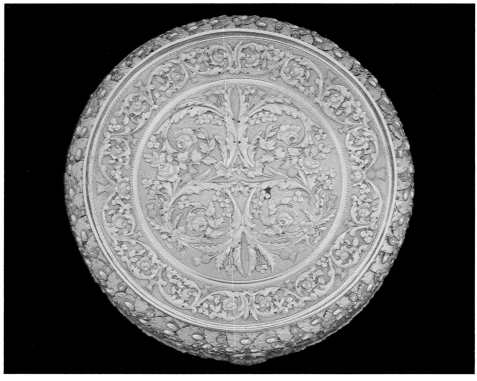

33

A George IV Rectangular Gold Table Snuff-Box, the cover embossed and chased with the arms of Beaumont and Chetham on mat ground within a circular scroll frame, surrounded by scrolling foliage and with animals at the corners, the sides and base with engine-turned waved panels, the sides bordered by chased scrolling foliage and flowers, the base with an *en suite* border to the cover, with mascaron and scroll thumbpiece.

9cm (3½ in.) long, maker A. J. Strachan, London, 1825.

For the maker cf. no. 26 of this catalogue.

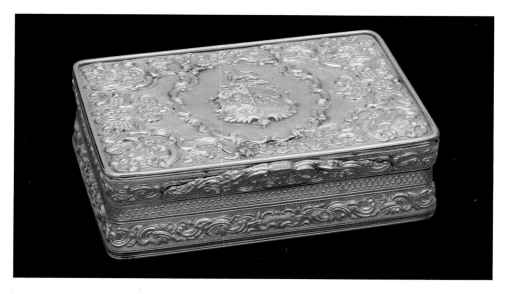

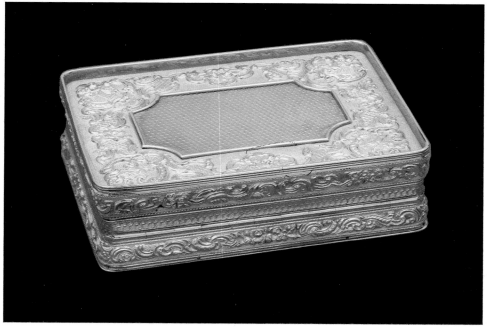

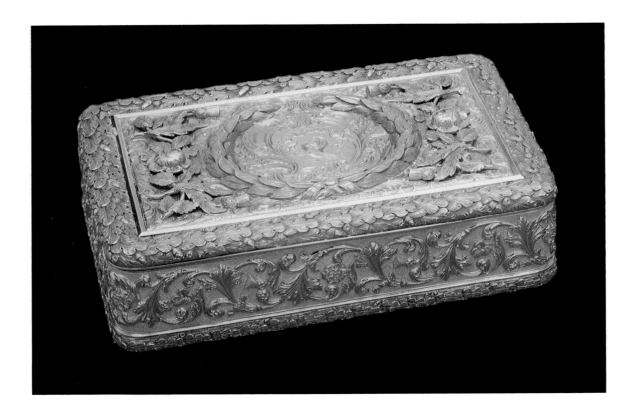

34

A George IV Large Rectangular Two-Colour Gold Table Snuff-Box,
the cover engraved with the Moncrieff crest in a chased laurel-leaf crown,
flanked on each side with raised thistles and roses, within a wide frame of
oak-leaf and acorns, the sides and base with scrolling acanthus foliage on
matted ground, the base engraved with swirling scrolling foliage, the
interior to the cover inscribed 'Presented/to/Hugh Moncrieff Esquire/by/
His/Friend/Robert Napier/Engineer/Lancefield—4 August 1840'.

11.4cm (4½ in) long, maker John Linnit, London, 1835, 18kt.

Provenance: The Misses Moncrieff, Christie's, London, November 30,
 1971, lot 87

John Linnit (1833-4) entered a first mark as goldworker in partnership with
William Atkinson, July 24, 1809 with address at 15 Fountain Court, Strand.
He entered three further marks with addresses at 9 Craven Buildings, Drury
Lane (1815) and at Argyle Place, Regent Street (1840).

Robert Cornelis Napier (Napier of Magdala), C.B., K.C.B., 1st Baron
(1810-1890), British Field Marshal. He entered the Bengal Engineers from
Addiscombe College in 1826 and arrived in India 1828. That year he laid out
the new hill station at Darjeeling. He took part as commanding engineer in
various campaigns culminating in the attack at Lucknow in 1858, as well as
in expeditions to China and Abyssinia. For his services he received the
thanks of Parliament, a pension, a peerage, the K.G., K.C.B., and the
Freedoms of the cities of London and Edinburgh.

Germany

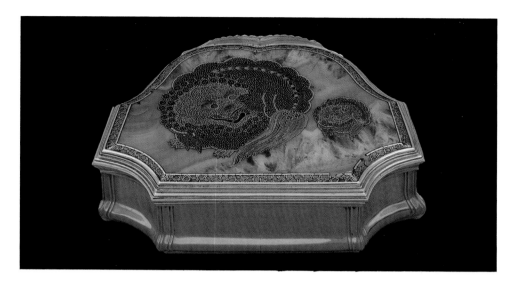

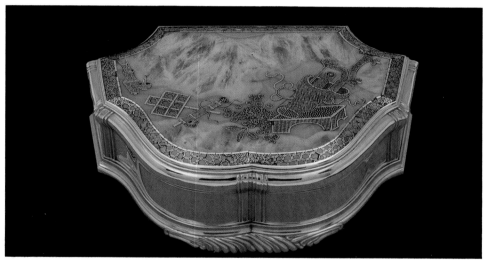

35

A Cartouche-Shaped Hardstone and Gold Chinoiserie Snuff-Box, the quartz cover and base set in gold and silver mosaic and *lacque burgauté* with two Fo dogs (cover) and a Chinoiserie still-life (base), with plain burnished gold sides, reeded mounts and scroll thumbpiece.

8.8cm (3½ in) long, from the workshop of Johann Martin Heinrici, Dresden, circa 1740-50, unmarked.

Johann Martin Heinrici, born in Lindau 1711, arrived in Meissen (Saxony) in 1741 where he worked most of his life and died 1786. Known as porcelain painter and engraver, he was equally famous for his snuff-boxes inlaid in silver and mother-of-pearl.

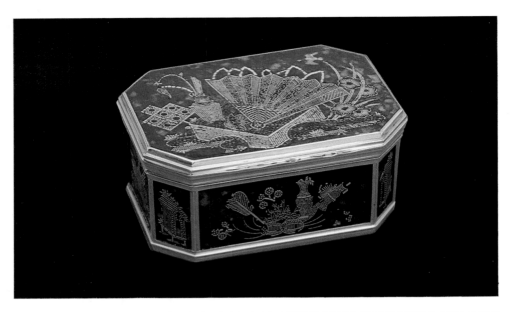

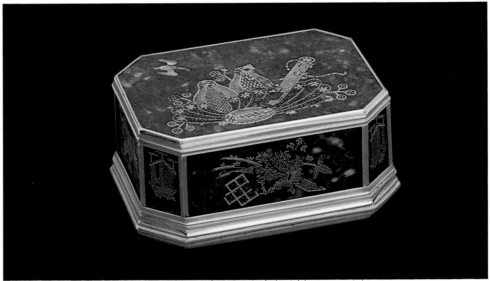

36

A Rectangular Gold-Mounted Hardstone Chinoiserie Snuff-Box with canted corners, the *à cage* lapis-lazuli panels to the cover, base and sides all inset in *piqué posé* gold, silver and *lacque burgauté* with Chinoiserie still-lives and birds.

6.3cm (2½ in) long, from the workshop of Johann Martin Heinrici, Dresden, circa 1750, unmarked.

For the maker cf. no. 35 of this catalogue.

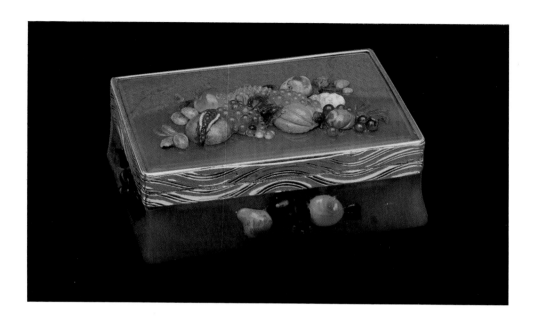

37

A RECTANGULAR GOLD-MOUNTED HARDSTONE SNUFF-BOX, the body of honey-coloured agate, the cover and sides applied with fruit in various polychrome semi-precious hardstones, including pomegranates, melons, apples, grapes, strawberries, plums, cherries and pears, the gold mounts chased with waves.

7.1cm (2¾ in) long, Dresden, circa 1760, unmarked.

The hardstone applications on this box are related in style to the work of the Hoffmann family in Dresden. For a signed box by F. L. Hoffmann applied with insects and fruit cf. A. K. Snowman, ppl. 539/40.

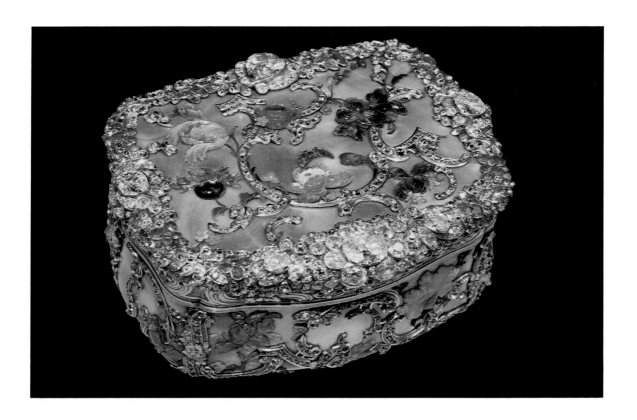

38

A Frederick The Great Cartouche-Shaped Jewelled Mother-of-Pearl, Hardstone and Vari-Coloured Gold Snuff-Box, applied on all sides with pink mother-of-pearl plaques, the cover encrusted with flowers in citrine, amethysts and foiled quartzes, including a peony, roses and carnations and numerous turquoise forget-me-nots, surrounded by gold rococo scrolls inset with circular-cut diamonds, the outer border with three large cushion-shaped and one pear-shaped diamond on pink foil, profusely inset with circular-cut diamonds, some on yellow and green foil, forming flowers and scrolls and with eight ruby-set flower-heads; the sides decorated *en suite* to the cover, the corners chased with three-colour gold flowers; the base applied with gold rococo scrolls inset with circular-cut diamonds, the outer border chased with three-colour gold flowers alternating with diamond-set scrolls; the gold mount to the cover chased with three-colour gold flower sprays and burnished gold scrolls on *sablé* ground.

10.4cm (3¹³⁄₁₆ in) long, Berlin, circa 1760-5, unmarked, in contemporary fitted dark shagreen case.

Provenance: King Frederick the Great of Prussia
The Dukes of Anhalt-Dessau
Christie's, Geneva, *Important Gold Boxes,* May 11, 1982, lot 176 (Property of a German Royal House)

Literature: Martin Klar, *Die Tabatieren Friedrichs des Grossen* in Der Cicerone XXI, 1929, ill. 4, p. 9
A. von Solodkoff and G. von Habsburg, *Die Tabatieren Friedrichs des Grossen,* in Kunst und Antiquitäten, May/June, 1983, p. 39

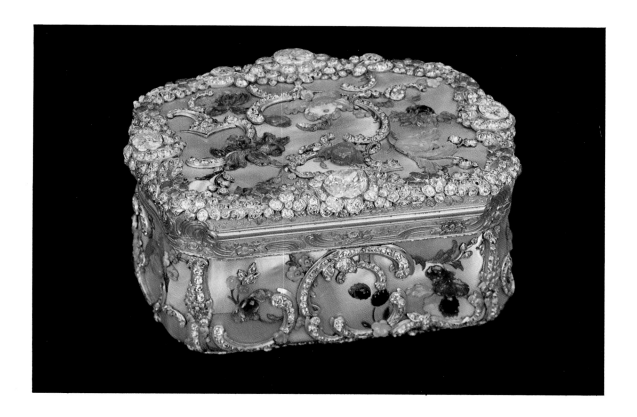

Frederick the Great of Prussia (1712-1786) is known to us today as the most assiduous collector of snuff-boxes of all the 18th Century. His name is connected with a very specific type of box mostly of unusually large format and heavily encrusted with diamonds. Specialists assume that Frederick may have possessed as many as 300 snuff-boxes. Many of these are mentioned in the *Schatullenrechnungen* (Merseburg Archives) partly published by W. Seidel, *Die Prunkdosen Friedrichs des Grossen,* in Das Hohenzollern Jahrbuch V, 1901, S. 74-86. In the lists established after the King's death some 120 boxes are mentioned in bulk. Very few of these magnificent snuff-boxes, considered today as the epitome of 18th Century luxury, have survived, due to their large intrinsic value. Seidel, *op. cit.,* gives a list of 17 boxes which were known at that time. Four boxes were added by Martin Klar, *Die Tabatieren Friedrichs des Grossen,* in Der Cicerone XXI, 1929, p. 7 ff, including the present one. An up-to-date list was published by Dr. Winifried Baer, *Ors et Pierres, des Boîtes de Frédéric-le-Grand,* in Connaissance des Arts, December 1980, no. 346, pp. 100-105, while further examples, only recently come to light, were added by A. von Solodkoff and G. von Habsburg, *op. cit.,* pp. 36-42.

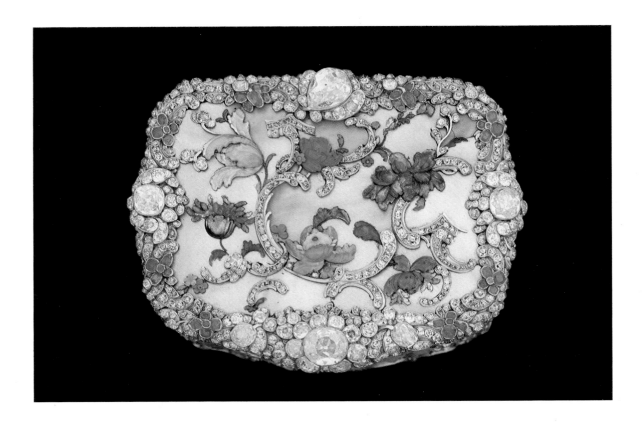

The extant 26 examples are mostly in museums: eight from the Prussian Imperial Collection in Schloss Charlottenburg in Berlin, three from the same Collection in Burg Hohenzollern (badly damaged when stolen 1953 and recuperated without their diamond encrustations), two in the Hermitage Treasury (Leningrad), two from the King Farouk collection (one in the Robert Lehman Bequest, Metropolitan Museum, the other in a New York private collection), one in the collection of H.M. Queen Elizabeth II, one from the Dohna-Schlobitten Collection (Private Collection, England), one in the Grand Ducal Hessen-Darmstadt family, one in the Louvre from the Philippe Lenoir Bequest, one from the collection of H.M. the Queen of the Hellenes (Sotheby, June 10, 1974, lot 26), and further examples in private collections in the United States, England, Switzerland and Germany.

The *Schatullenrechnungen* mention a number of boxes in some detail when they were acquired by the King from either the retailer C. L. Gotzkovsky or from the gold-smiths active for him in Berlin. Invoices from the jewellers Daniel Baudesson (1716-1785), André Jordan (1708-1777), his brother Jean-Louis (1712-1759), and from Veitel Ephraim and Sons to the King's Court dating from 1742 to 1775 describe these boxes as *tabatières très riches en brillants,* with prices ranging from 4,200 to 12,000 thalers (cf. Seidel, *op. cit.,* p. 84). Unfortunately, no description allows an identification or an attribution of the known snuff-boxes.

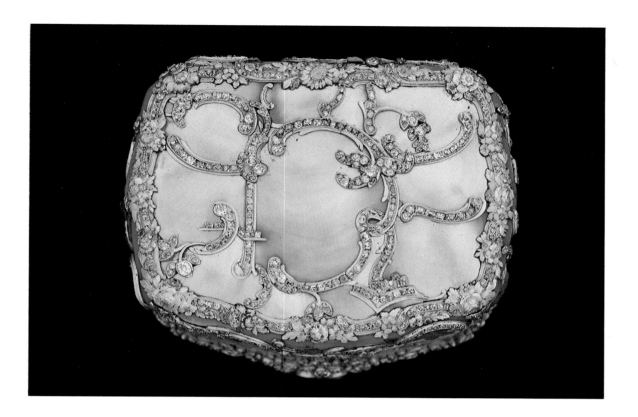

Daniel Baudesson is the best documented of the goldsmiths working for the *Fabrique Royale de Berlin*. A number of his boxes with typically pastel-coloured enamels are signed with his initials or full signature. Possibly the most influential goldsmith active for Frederick the Great was Jean-Guillaume-George Krüger (1728-1791), who arrived in Berlin in 1753. Some 40 drawings and watercolours of his survive in the Berliner Kupferstichkabinett, all of them very closely connected with the *friderizianisch* type of snuff-box. Two of these served as models for boxes in Schloss Charlottenburg and the Hessen-Darmstadt Collections (cf. Klar, *op. cit.,* pl. 1 and ill. 6, and Baer, *op. cit.,* p. 105). Others also known to have produced boxes for Frederick were the painter Daniel Chodowiecki, the jewellers Johann-Jakob Schwanfelder, Phillip Colivaux, Jean Oudot and Pierre Lautier. the King personally is known to have made designs for some of his own snuff-boxes.

The majority of Potsdam boxes are hardstone—mostly green chrysoprase, some in figured agate *(Festungsachat),* heavily encrusted in vari-coloured gold and profusely inset with diamonds of all shapes and sizes, many foiled with coloured tinsel. The present box seems to be the only example using a mother-of-pearl background for the hardstone flower decoration (the *Schatullenrechnungen* mention a box in *Perlmutter mit goldenen Nägeln* (16. VIII. 1749). The most similar in style hitherto known is the box from the Greek Royal Collection, with its polychrome flower sprays on burnished gold ground. Both are definitely based on designs of the type produced by Krüger.

The boxes from the *Fabrique Royale de Berlin* were considered by Frederick to be his own personal property. Only in very exceptional cases were they given away by the King. One example was presented to the *Alter Dessauer* (Duke Leopold of Anhalt-Dessau, the celebrated Prussian Field-Marshal). The present box was apparently also given to a member of the same family, possibly to Duke Leopold III.

An Oval Gold-Mounted Hardstone Snuff-Box *(Steinzellen-mosaiktabatiere),* the cover applied with an enamel miniature of Mlle de Valois *in the style of Petitot,* three-quarters left, wearing an ermine-trimmed jewelled blue robe, pearl necklace and pearls in her hair, in a plain oval gold frame, inset in a lapis-lazuli panel, the outer frame set with oval cornelian discs, green jasper laurel leaves and yellow berries, the sides with oval lapis-lazuli panels, alternating with floral motifs in white, green and brown stone and with similar laurel swags, the base *en suite* to the cover.

8.8cm (3½ in) long, maker Johann Christian Neuber, Dresden, circa 1775-80, *stamped Neuber, Dresde* and *20 Kt,* and engraved 268 on flange.

Provenance: Viscount Bearstead, M.C.

Literature: R. and M. Norton, pl. 40
 A. Gonzales-Palacios, no. 22

Exhibited: *The British Antique Dealers Association Golden Jubilee Exhibition,* Victoria and Albert Museum, London 1968, no. 23 (ill. pl. 37)
 The Art of Mosaics and Monumental Silver, Victoria and Albert Museum, London, 1975
 The Los Angeles County Museum of Art (April 28/July 10, 1977)
 The High Museum, Atlanta (September 9/October 30, 1977)
 The Witte Memorial Museum, San Antonio (December 18/March 21, 1978)
 The Virginia Museum of Fine Arts, Richmond (September 12/October 22, 1978)
 The Seattle Art Museum, Seattle (November 29/January 14, 1979)

Johann Christian Neuber (1736-1806), was apprenticed to Johann Trechaeon at the age of 17. In 1762 he became citizen and goldsmith in Dresden. He married the daughter of Heinrich Dattel (Taddel), director of the *Grünes Gewölbe,* who was his teacher and to whom he succeeded in 1769. Neuber is mentioned as Court Jeweller from 1785 until 1805.

His first documented work 1769, was a table presented by the City of Freiberg to Elector Frederick Augustus, comprising 132 varieties of hardstone listed in a booklet. A gold and hardstone box dated 1770 is in the *Grünes Gewölbe* (Inv. 1933-2). Another in the Château de Breteuil dated 1780 retains its catalogue in a secret compartment.

Neuber was celebrated for his *Steinkabinettstabatieren* (with numbered hardstone panels) and his *Steinzellenmosaiktabatieren* (with small polychrome semi-precious stone plaques forming patterns). For all available information on this maker, cf. Walther Holzhausen, *Johann Christian Neuber,* Dresden 1935.

Charlotte Agläe, Mlle de Valois (1700-1761) daughter of Louis Philippe, Duc d'Orleans, Regent of France and Charlotte Jeanne de Montespan, married François III d'Este, Duke of Modena, June 21, 1720.

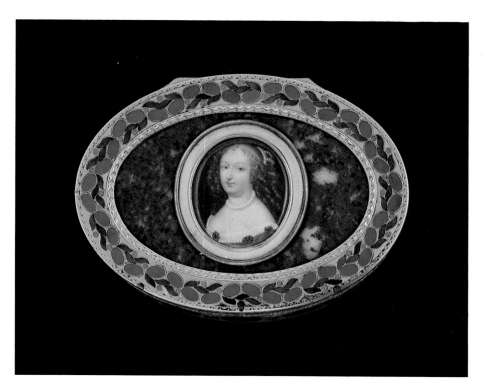

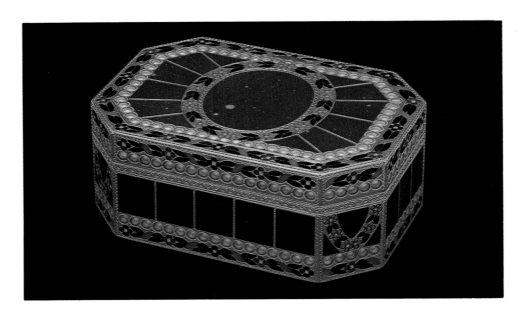

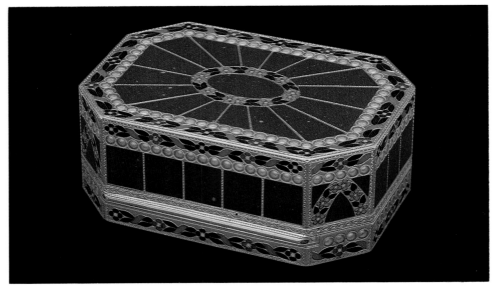

40

A RECTANGULAR GOLD-MOUNTED HARDSTONE SNUFF-BOX *(Steinzellen-mosaiktabatiere)* with canted corners, all panels set with brown jasper plaques, with turquoise forget-me-not and green jasper laurel-leaf wreaths to the cover and base, with imitation seed-pearl border and outer green jasper laurel-leaf red, green and yellow hardstone rosettes and agate ribbon frame.

8.2cm (3¼ in) long, from the workshop of Johann Christian Neuber, Dresden, circa 1780, unmarked.

Provenance: The late Lady McMahon, Christie's, London, November 25,
1970, lot 150
Sotheby's, Geneva, May 6, 1981, lot 20

For the maker cf. no. 39 of this catalogue.

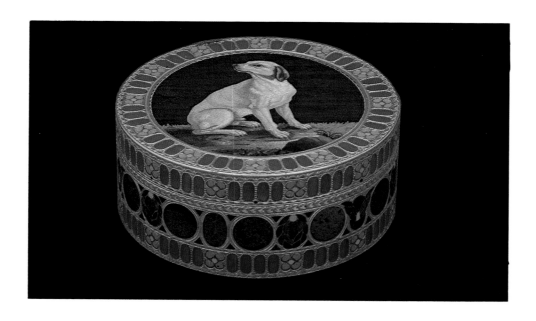

41

A CIRCULAR GOLD-MOUNTED HARDSTONE AND MOSAIC-BOX, the cover inset with a Roman mosaic panel of a white hound seated on its hind quarters on a grass surface, a blue sky behind, the base with a polychrome butterfly also on blue ground, each panel with a border of alternating three oval cornelian plaques and forget-me-nots in turquoise, the sides with a band of circular lapis-lazuli discs, interspersed with green jasper swags and wreaths.

7.7cm (3 in) diam., the box from the workshop of Johann Christian Neuber, Dresden, circa 1780, the mosaic attributed to G. Raffaeli.

Provenance: Sotheby's, Zurich, November 7, 1975, lot 84

Literature: A. Gonzales-Palacios, no. 23
Art Price Annual 1975/6, Munich, 1976, p. 178

Exhibited: cf. no. 39 of this catalogue for the itinerant exhibition at the Victoria and Albert Museum, London, and five American museums 1977/1979

For the maker cf. no. 39 of this catalogue.

For a box with a butterfly on white ground signed G. Raffaeli, cf. Domenico Petochi, p. 111. For boxes with almost identical hounds, cf. Petochi, figs. 21 and 22.

As in the case of nos. 7, 28, 59, and 62, this box also shows the wide distribution of Roman micromosaics throughout Europe.

France

42

A LOUIS XV RECTANGULAR JEWELLED AND ENAMELLED GOLD SNUFF-BOX, the cover enamelled *en plein* with Apollo holding a lyre and three putti on a bank of clouds on a diamond sunburst ground with enamelled roses, tulips, clematis and other flowers in a chased scroll border, the sides and base enamelled *en plein* with putti and emblems of the Arts and Sciences on similar and engraved ground framed by flowers *en suite*.

8cm (3⅛ in) long, maker Jean-François Breton, Paris, 1753, with the charge and discharge of Fermier Julien Berthe, engraved no. 27 on flange.

Provenance: Baron Carl von Rothschild, Frankfurt
 The Lord Rothschild Collection, Christie's, London, 30 June, 1982, lot 55

Jean-François Breton (active 1737-1791) was apprenticed at the age of 14 to Etienne Pollet. Appointed master goldsmith on September 7, 1737, his address was initially at the Rue de la Fromagerie and after 1769 at the Quai des Morfondus. He was elected *Garde* 1756/7 by the corporation of goldsmiths and again in 1772. Breton was mainly a jeweller and hitherto only seven gold boxes seem to be known by him—to which this one can now be added.

For the subjects, adapted from engravings after paintings by Boucher, cf. J. R. Pierette, *L'Oeuvre gravée de F. Boucher,* Collection Edmond de Rothschild, 1978, no. 194 (Apollo) and nos. 1295-1310 (putti).

The allegorical subject of Apollo wearing a laurel crown may be seen in connection with Louis XV; Boucher is known to have painted the sun-god with the features of this monarch.

There is no doubt that this lavish box, which epitomizes the art of the Paris goldsmith, was made for a member of the Court, perhaps the King himself.

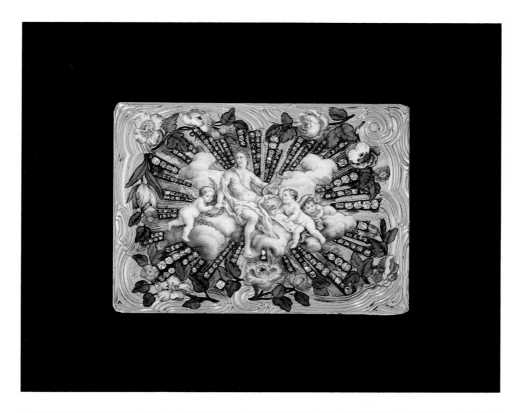

43

A Louis XV Ingot-Shaped Gold Double Snuff-Box decorated on all sides with bold horizontal engine-turned reeding and diagonal waved bands.

8cm (3⅛ in) long, maker Jean Ducrollay, Paris, 1754, with the charge and discharge of Fermier Julien Berthe.

Literature: H. Rickets, p. 17 (col. ill.)

Exhibited: The Somerset House Art Treasures Exhibition, London, 1979, no. J3

Jean Ducrollay (active 1734-61) was one of the best-known Paris jewellers and gold box makers. Apprenticed at the age of 13 to Jean Drais, he was received master goldsmith on July 26, 1734. His address was originally Rue Lamoignon, and later Place Dauphine. The corporation of goldsmiths named him *Commissaire du grand bureau des pauvres*.

This *boîte à deux tabacs* is an unusually fine example of its kind, deceptive in its simplicity but obviously made for a *connoisseur*. A very similar box by Louis-Guillaume Casse, Paris, 1755, was sold by Sotheby's, London, June 21, 1982, lot 43.

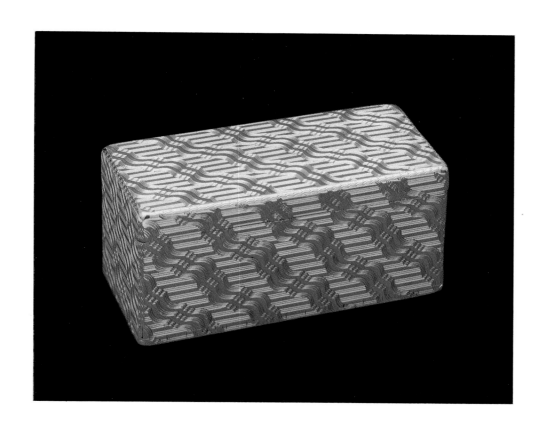

44

A LOUIS XV ENAMELLED GOLD SNUFF-BOX enamelled *en plein* with four spaniels in an interior with a dog kennel and yellow drapery (cover), three dogs and a cat (sides), and a still-life of bottles, glasses and fruit on a ledge (base), the cover and base with a shaped chased gold frame, a painted band of yellow-brown scrolls and imitated lapis-lazuli panels and an outer bright-cut gold border, the sides also with alternating imitated lapis-lazuli panels and painted pink rosettes in waved chased gold setting.

7cm (2¾ in) long, maker François-Nicolas Génard, Paris, 1763, with the charge and discharge of Fermier Jean-Jacques Prévost.

Provenance: Arturo Lopez-Willshaw
R. Penard y Fernandez, Paris, Palais Galliera, December 7, 1960, no. 202, p. LXX
The Ortiz-Patiño Collection I, Christie's, London, June 27, 1973, lot 20

Literature: A. K. Snowman, *The Ortiz-Patiño Collection,* no. 34, p. 78 (col. ill.) and p. 79

Exhibited: *British Antique Dealers Association Golden Jubilee Exhibition,* Victoria and Albert Museum, London, 1968, no. 51
A Thousand Years of Enamel, Wartski, London, 1971, no. 10

François-Nicolas Génard (active 1754-1790), was apprenticed to Louis Mailly, November 5, 1737. On January 19, 1754 he became master goldsmith, sponsored by Noël Hardivilliers. His address was Cours Neuve du Palais (1754-1787), Rue du Martrois (1788), and Rue de la Tixanderie (1789-90).

Very few boxes by Génard are known. An example dated 1763-4 with grisaille scenes on red ground is in the Louvre (cf. S. Grandjean, no. 113). For a lady's snuff-box, also with grisaille subjects, cf. Christie's, Geneva, May 10, 1983, lot 66. For an oval gold box chased with putti, cf. the same sale, lot 63.

The pet dogs and cats on this box are probably those of Madame de Pompadour. A portrait by François Boucher of Mme. de Pompadour with her spaniel Inès, very similar to one of the dogs on the cover of this box is in the Wallace Collection (cf. Ananoff, *Boucher Vol. II,* no. 522). They are also similar to those of her two dogs Inès and Mimi painted on a Sèvres porcelain plaque in the Waddesdon Manor Collection (cf. Sven Eriksen, *The James A. de Rothschild Collection, Sèvres Porcelain,* 1968, no. 42a). An upholstered kennel probably having belonged to Marie-Antoinette and reminiscent of the one shown on the cover is in the Wrightsman Collection.

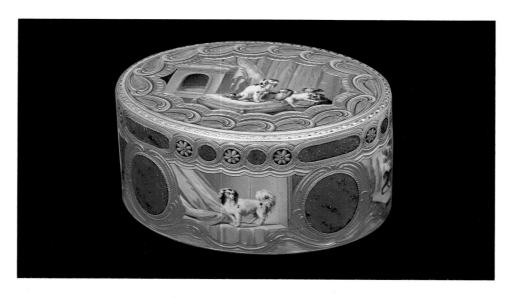

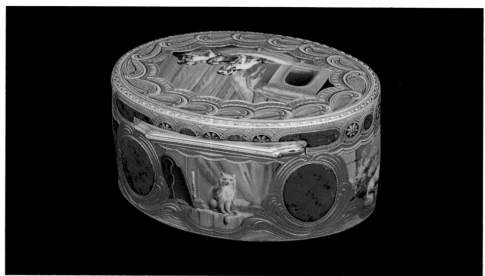

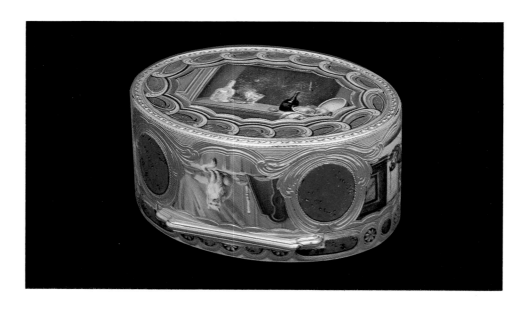

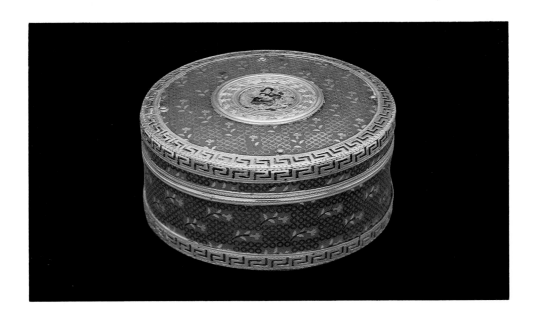

45

A Louis XV Circular Gold-Mounted Red Lacquer Box, the cover applied with a circular engine-turned plaque engraved and enamelled in blue with a fox and a crane, within a laurel-wreath border, the cover, sides and base of red lacquer inset with a decoration of recurring silver circles, red, grey and yellow gold carnations, surrounded or flanked by gold borders pierced with a key-pattern, the interior to the cover inscribed "This Box belonged to/Governor Holwell/who commanded at/Calcutta/one of the 23 Survivors/of the 146 immured in the/Black Hole/of that Fortress/1756".

6.8cm (2¾ in) diam., Paris, 1765 (?) with the charge of Fermier Jean-Jacques Prévost, maker's mark illegible.

John Zephania Holwell commanded the British garrison remaining in Calcutta in 1756 when the Nawab of Bengal, Suraj-ud-Dowlah captured Fort William. After a short resistance the Europeans surrendered and on June 20th in the intensive heat 146 prisoners were forced into the guard-room measuring 18 × 14ft for the night. Next morning only 23 were taken out alive, among them Holwell, who left an account of the awful suffering endured in the "Black Hole".

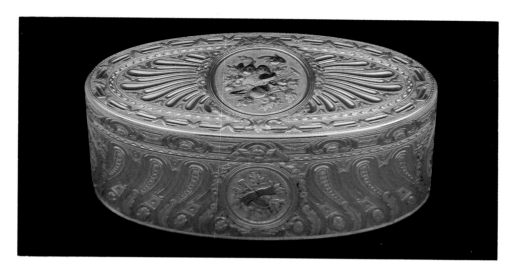

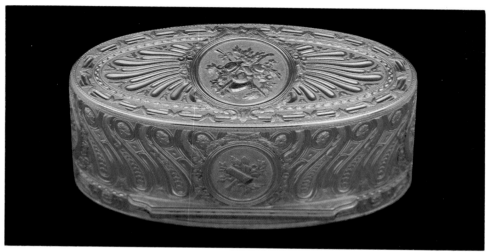

46

A LOUIS XV OVAL QUATRE-COULEUR GOLD SNUFF-BOX, the cover, sides and base with oval medallions chased with emblems of Love in four-colour gold on *sablé* ground, each surrounded by laurel sprays and in panels chased with deep swirling flutes and husks on *sablé* ground with waved borders and *sablé* gold outer frame chased with interweaving bands and foliage.

9.2cm (3⁹⁄₁₆ in) long, maker François-Guillaume Tiron, Paris, 1768, with the charge and discharge of Fermier Julien Alaterre.

François-Guillaume Tiron became master goldsmith August 4, 1747, sponsored by Pierre Tiron with address at rue St. Louis, *à la pomme d'or,* and later at rue Thibautodé. He is no longer mentioned in the list of goldsmiths in 1782.

This box is a very fine example of the late Louis XV period with its crisp and deep-cut decoration combining the art of engine-turning, chasing and matting of surfaces and the virtuoso use of four-colour gold.

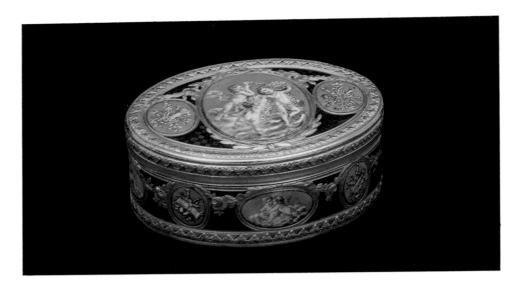

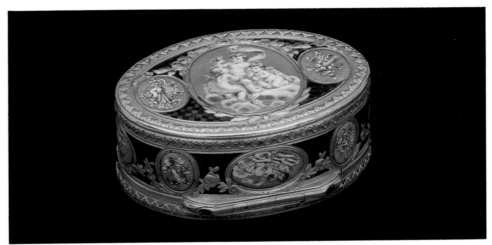

47

A Louis XVI Oval Enamelled Two-Colour Gold Snuff-Box, the cover, base and sides painted *en plein* in *grisaille* on lime-green ground with groups of putti and musical trophies, all allegorical of Love, conjoined by chased gold flower and laurel swags and set in panels of chocolate-brown translucent enamel over engine-turned chequer backgrounds with stylized leaf borders.

6.6cm (2⁹/₁₆ in) long, indistinct maker's mark of Melchior-René Barre (?), Paris, 1774, with the charge and discharge of Fermier Julien Alaterre.

Melchior-René Barre (active 1768-1792) was apprenticed with Jean Frémin January 9, 1751 and became master goldsmith June 11, 1768, sponsored by J.-L. Bouillerot. His addresses were Place Dauphine (1772), Quai des Orfèvres (1774) and Rue St. Honoré (1781).

A classical example of a Louis XVI box in rather unusual colours, showing subjects based on the art of François Boucher.

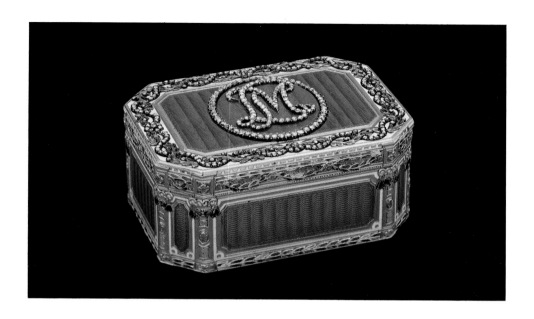

48

A Louis XVI Rectangular Gemset and Enamelled Gold Snuff-Box with canted corners, the cover applied with a diamond-set monogram LM within a diamond-set circle on a panel on waved scarlet guilloché enamel, the white enamel border chased and applied with an interweaving rose-diamond-set ribbon and continuous laurel sprays with green enamel leaves, red enamel and rose-diamond-set berries, the sides and base with similar panels bordered in white with pilasters at the corners and with laurel-leaf bands and suspended swags.

6.8cm (2¾ in) long, maker Joseph-Etienne Blerzy, Paris, 1775, with the charge of Fermier Jean-Baptiste Fouache, and contemporary export mark of a camel's head, stamped no. 366 on the flange.

Provenance: The René Fribourg Collection, Sotheby's, London, October 14, 1963, lot 296
The Henry Ford II Collection, Sotheby's, New York, February 25, 1978, lot 23

Joseph-Etienne Blerzy (active 1768-1806), was apprenticed 1770 to François-Joachim Aubert. He became master goldsmith March 12, 1768, sponsored by Aubert. His address was at the Pont du Change *A la Ville de Leipzig,* and later at 41 rue de la Monnaie. Blerzy can be considered as one of the best and certainly most prolific box makers of the late 18th Century.

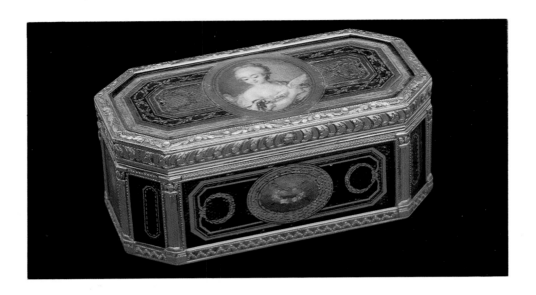

49

A Louis XVI Rectangular Gold-Mounted Verre-Eglomise Snuff-Box
with canted corners, the cover painted with a girl, a dog and a dove *after
Boucher,* the base and sides painted with symbols of Love, all in oval
medallions, the yellow, blue, green and brown panels painted to simulate
guilloché enamel gilt with wreaths and sprays, with chased gold borders of
indented pellets, laurel leaves and stylized leaves and pilasters at each corner,
the interior to the cover inscribed "Charles Duke of Richmond/to Sir Francis
Freeling/As a token of his Esteem and Friendship/5th July 1834".

8.4cm (3¼ in) long, maker Pierre-Robert Dezarot, Paris, 1776, with charge
and discharge of Fermier Jean-Baptiste Fouache, stamped no. 16 on flange.

Pierre Robert Dezarot, apprenticed 1754 to François-Simon Charbonné,
became master goldsmith January 18, 1775. He is last mentioned 1781.

Charles Lennox, Duke of Richmond (1791-1841) served as lieutenant colonel
during the Peninsular War 1814 and as ADC to the Prince of Orange during
the Battle of Waterloo. M.P. for Chichester 1812-19, Military ADC to
William IV, 1832 and to Queen Victoria 1837-41. Member of the Grey
cabinet, he resigned 1834 and joined Peel as one of the new Conservative
Party.

Sir Francis Freeling (1764-1836) Bt., postal reformer and book collector, was
a Fellow of the Society of Antiquaries 1801 and one of the founding
members of the Roxburgh Club 1812.

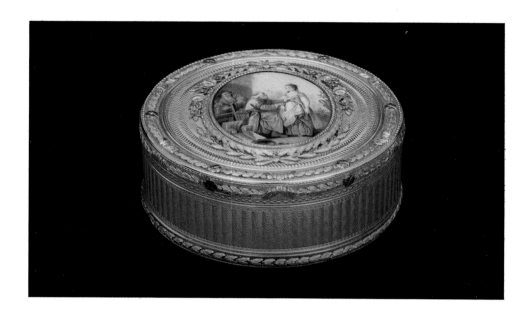

50

A LOUIS XVI CIRCULAR ENGINE-TURNED THREE-COLOUR GOLD BOX, the cover with an oval enamel miniature of a young love-sick lady visiting a doctor, with suspended three-colour gold flower-swags above and laurel-sprays beneath, the cover, sides and base decorated with waved panels bordered by yellow-gold laurel-leaf bands interspersed with grey-gold rosettes and red-gold foliage, the base unscrewing to reveal a secret compartment for a miniature.

7cm (2¾ in) diam., maker Charles Le Bastier, Paris, 1777, with the charge and discharge of Fermier Jean-Baptiste Fouache and stamped no. 840.

Provenance: Sotheby's, London, March 7, 1980, lot 33 (col. ill.)

Charles le Bastier (active 1754-1783), was apprenticed October 3, 1738 to Gabriel Vougny. He became master goldsmith December 16, 1754, sponsored by Jean Moynat. His address was at Rue Thevenot. As one of the most successful makers of boxes and étuis, he was classified as 9th in his trade 1774. He collaborated with Jean-François Garand and Grancher of *Du petit Dunquerque* both of whom retailed boxes by Le Bastier. The Louvre owns 13 boxes by this maker (cf. S. Grandjean, nos. 138-150).

The miniature is a *pastiche* based on two paintings by Jean-Baptiste Leprince (1739-1781) from the *Suites Russes*.

51

A Louis XVI Oval Jewelled and Enamelled Gold Snuff-Box, the cover applied with a miniature of a girl in Classical dress sacrificing at an altar in a landscape setting, within a circular-cut diamond frame flanked by rose-diamond bands, set in an opalescent lavender panel with waved engine-turned background painted *en camaïeu mauve* with dentritic motifs, with a border of opalescent pellets and similar diamond-set outer frame, the sides and base with panels *en suite* within opalescent pellet, green and red laurel-leaf borders.

8.3cm (3¼ in) long, maker Jean-Joseph Barrière, Paris, 1779, with the charge of Fermier Jean-Baptiste Fouache, a fleur-de-lys, and stamped no. 2009 on flange.

Jean-Joseph Barrière (active 1763-1793), was apprenticed 1750 to Nicolas Dumoussay. Sponsored by Henri Delobel, he was received *Maître* January 17, 1763. His address was at the Pont Notre Dame until 1786, then at Coq St. Honoré.

This box is a classical example of the type made in Paris during the 1770s and 1780s mainly by Jean-Joseph Barrière and Joseph-Etienne Blerzy. They were emulated outside of France in Switzerland (cf. no. 1 of this catalogue) and in Russia (cf. A. K. Snowman, pl. 639/40).

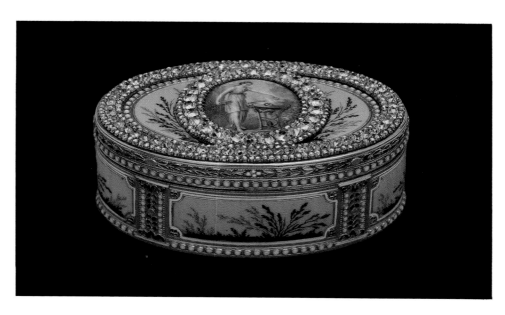

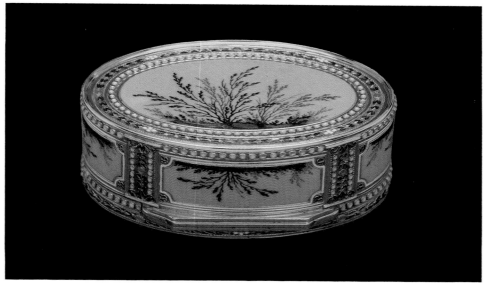

52

A Louis XVI Rectangular Gold Box Set with Miniatures, with rounded corners, the grisaille panels painted with the Triumph of Bacchus *signed P. M. de Gault,* the sides and base with other bacchanalian subjects, the mounts enamelled with interweaving green ribbons centring on opalescent pellets with fluted pilasters at the corners.

8.7cm (3⅜ in) long, maker Adrien-Jean-Maximilien Vachette, Paris, 1782, with the charge of Fermier Henri Clavel and various other unidentified marks on the flange.

Provenance: Christie's, London, March 27, 1973, lot 192, pl. 5

Adrien-Jean-Maximilien Vachette (active 1779-1839) was born at Cauffry 1753, and received *Maître* July 21, 1779, sponsored by Pierre-François Drais. His address was at the Place Dauphine.

Vachette was one of the most prolific and eclectic goldsmiths of the late 18th/early 19th century, producing gold boxes in many styles and using all sorts of materials including mosaics, lacquer, glass, hardstone, and enamels. The Louvre has 31 boxes by this one maker (cf. S. Grandjean, no. 200-215, 352-365). For a similar box by Vachette in the Louvre dated 1784/5, cf. S. Grandjean, no. 207.

Pierre-Marie Gault de St. Germain (1754-1842), miniature painter and author invented and then specialized in grisaille scenes after the Antique. De Gault and his invention must have been most popular during the last quarter of the 18th century, as proved by the large number of boxes set with his miniatures still in existence.

The subjects of this box are after Parmigianino's "Triumph of Silenus and Bacchus" engraved by Anne Claude Philippe de Tubières, Comte de Caylus (1692-1765).

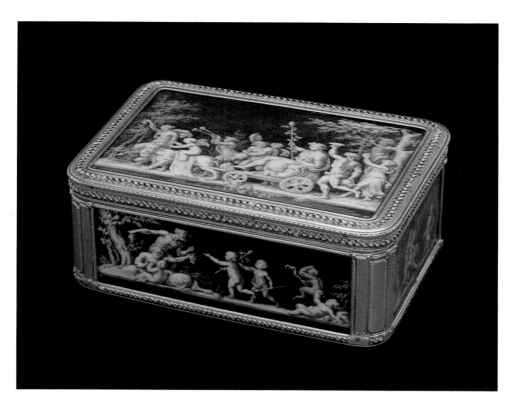

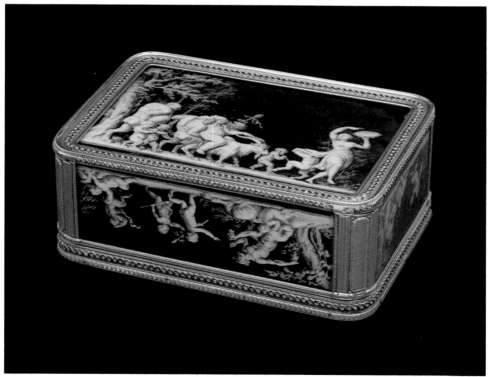

53

A LOUIS XVI RECTANGULAR GOLD TABLE SNUFF-BOX with canted corners, the cover, base and sides with oval enamel miniatures of peasant girls in interiors *after Greuze* flanked by ovals decorated in blue guilloché enamel and burnished gold spandrels, all borders with bands of continuous blue enamel circles between similar enamel stripes, with pilasters at each corner.

7.8cm (3 in) long, maker Denis-Rémy Boutry (?), Paris, 1785, with the charge and discharge of Fermier Henri Clavel, inscribed with retailer's mark *Ouizille et Drais à Paris* on the flange.

Denis-Rémy Boutry, son of the goldsmith Denis Boutry, was born 1710. Received *Maître* December 20, 1754, he was listed at the Croix-Rouge in 1759 and at the Rue des Orfèvres in 1781. He was active until 1762 when he returned his *poinçon*.

The subjects on this box include *La Tricoteuse Endormie* and *La Devineuse* both based on paintings by Greuze, exhibited at the Salon of 1759 (cf. Jean Martin, *Catalogue Raisonné de l'Oeuvre de Greuze,* 1908, no. 518 and 492). The *Tricoteuse* was engraved by Donat-Jardinier (cf. Smith VIII, p. 409, no. 59).

This type of subject was immensely popular on French 18th century boxes. For a box by Louis Roucel of similar shape, also with enamels after Greuze, cf. S. Grandjean, no. 184.

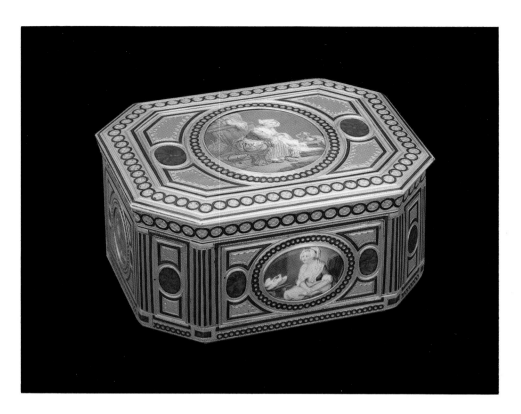

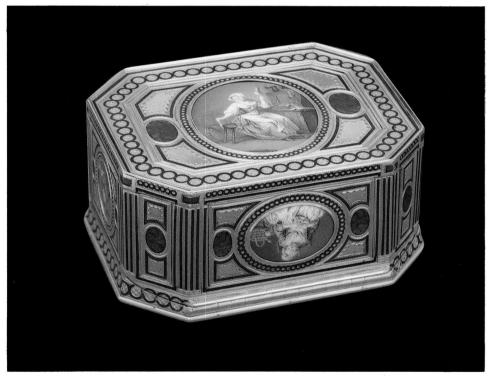

54

A LOUIS XVI OVAL QUATRE-COULEUR GOLD MUSICAL AUTOMATON TABLE SNUFF-BOX, the glazed hinged cover showing two couples in a landscape with a castle, with an automaton galleon and a pinnace on the horizon sailing across rolling waves on a matted gold background, the base with a harbour scene and figures launching a boat, the sides pierced for sound and chased with four medallions emblematic of shipping, the borders to the cover and base chased with leaves and berries, the sides with interweaving ribbons and laurel sprays, drapery and flower swags, the musical carillon playing on four bells, activated by a button on the side.

8cm (3³⁄₁₆ in) long, the box by Joseph-Etienne Blerzy, Paris, 1786, with the charge and discharge of Fermier Henri Clavel, stamped 227 on the flange, the mechanism Geneva, circa 1780.

Provenance: Collection Berry Hill, New York
 The Sydney Lamon Estate, Christie's, New York, June 14, 1982, lot 174A

Literature: Alfred Chapuis and Edmond Droz, *Les Automates,* London 1949, fig. 222/3

For the maker cf. no. 48 of this catalogue.

This is a rare case of a leading Parisian box-maker using a Swiss mechanism and basically following a Geneva-type model (cf. no. 2 of this catalogue).

Another gold box with automaton seascape was in the Sandoz Collection (cf. Chapuis and Droz, *op. cit.,* fig. 224)

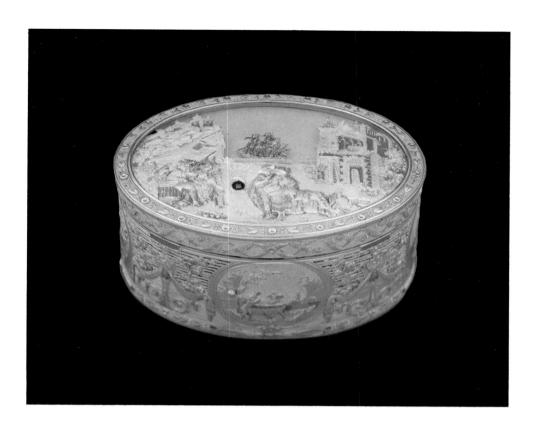

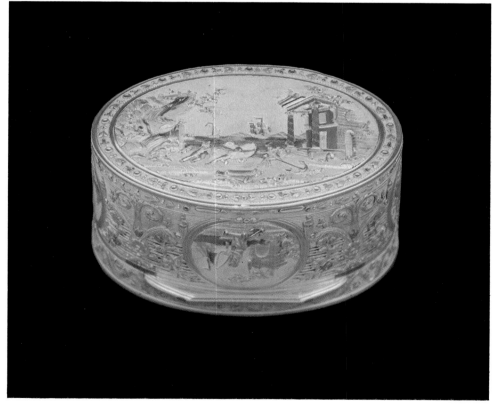

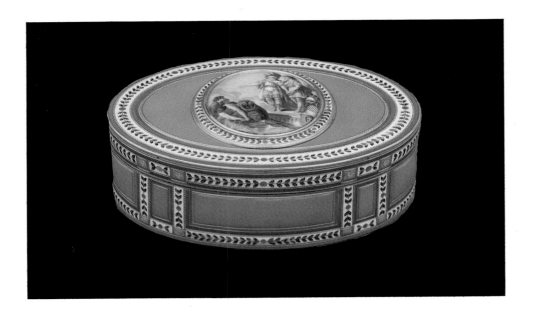

55

A Louis XVI Oval Enamelled Gold Snuff-Box, the cover with an oval enamel miniature of two soldiers in Classical dress embarking, the cover, base and sides with panels of opaque mauve enamel, within white opaque enamel frames decorated with translucent green leaves and red berries, and flanked by two lime-green enamel bands.

8.3cm (3¼ in) long, maker Joseph-Etienne Blerzy, Paris, 1786, with the charge and discharge of Fermier Henri Clavel, and stamped no. 886 on flange.

For this maker cf. no. 48 of this catalogue.

A similar mauve enamel box by Blerzy was sold by Sotheby's, Monaco, 29 November 1975, lot 17.

For a Swiss box in the Louvre with an identical miniature on the cover cf. S. Grandjean, no. 550.

Oval snuff-boxes with panels of monochrome translucent or opaque enamel were extremely popular during the reign of Louis XVI (cf. A. K. Snowman, p. 401 and S. Grandjean, nos. 34-39, for similar examples by Blerzy).

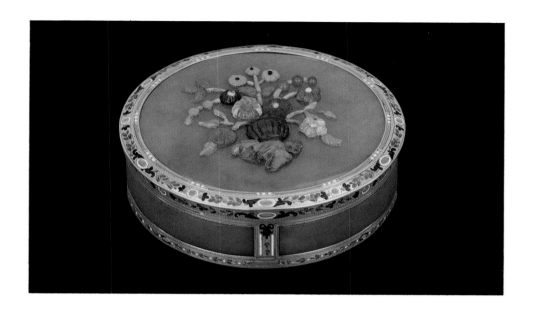

56

A Louis XVI Circular Gold-Mounted Hardstone Box, the cover, base and sides of pale-green chrysoprase mounted *à cage,* the cover applied with a vase of flowers in lapis-lazuli, turquoise, carnelian, agates and other hardstones, the gold mount enamelled in *basse-taille* with green and blue foliage, turquoise and white pellets and discs.

7.3cm (2⅞ in) diam., Paris, 1788, with the charge of Fermier Henri Clavel, maker's mark illegible, engraved no. 130 on the flange, the panels Berlin, circa 1780.

Provenance: The late Baron Max de Goldschmidt-Rothschild and the Baronne de Becker, Sotheby's, Monaco, November 29, 1975, lot 145

Exhibited: Cf. no. 39 of this catalogue for the itinerant exhibition at the Victoria and Albert Museum, London and five American museums, 1977/9

As Swiss enamels and Italians mosaics, the popular German enamels and hardstones from Dresden and Berlin were exported to Paris for mounting.

57

A Louis XVI Oblong Gold-Mounted Verre-Eglomise Snuff-Box with canted corners, the panels painted in gold on marbled red ground with ten allegorical scenes depicting the history of Rome, Coriolanus at the gates of Rome (cover), Cornelia, daughter of Scipio the African receiving her mother and her children (base), Belisarius being led to the Temple (front), the rape of the Sabine women (back), and allegories of the four rivers of the Roman Empire (sides), with stiff-leaf and burnished gold borders.

10.2cm (4 in) long, maker Joseph-Etienne Blerzy, Paris, 1789, with the discharge of Fermier Jean-François Kalendrin.

Provenance: Baroness Caroline Rulh, Sotheby's, London, March 6, 1967, lot 133
The J. Ortiz-Patiño Collection (III), Christie's, London, June 26, 1974, lot 9

Literature: A. K. Snowman, col. pl. XLIII
A. K. Snowman, *The J. Ortiz-Patiño Catalogue,* no. 63

Exhibited: The Somerset House Art Treasures Exhibition, London 1979, no. J4

For the maker cf. no. 48 of this catalogue.

The subjects on the sides of this box are copied from Antonio Canova's *Figuri in movimento,* Passagno, Gipsoteca (Inv. no. 135), cf. Mario Praz, *L'opera completa di Antonio Canova,* no. D18

A box of similar inspiration and technique by Adrien Vachette also dated 1789, was in the Fockema Collection, Christie's, London, 18 November, 1969, lot 74.

This box is one of the finest of its kind dating from the very end of the reign of Louis XVI. The use of edifying heroic subjects from Roman history in works of art is typical for this pre-revolutionary period of which Blerzy was one of the main exponents.

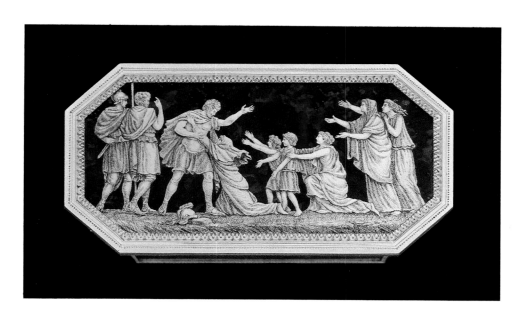

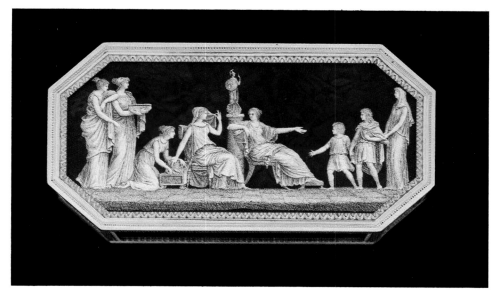

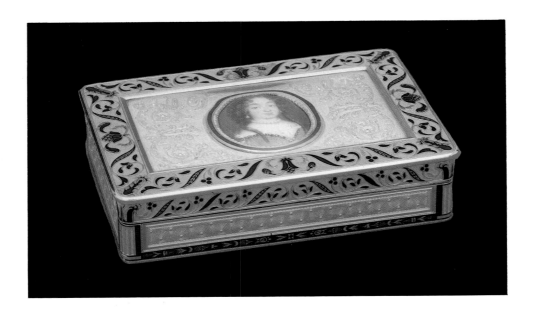

58

A Directoire Rectangular Enamelled Gold Snuff-Box, the cover inset with an oval enamelled miniature of a lady full face, wearing a lace-trimmed orange dress, pearl necklace and earrings, *in the manner of Jean Petitot,* on a glazed panel chased with acanthus foliage on matted ground, the outer frame with scrolling foliage enamelled in blue on matted gold ground, the sides and base engine-turned with wave-and-pellet motifs and with similar borders.

8.4cm (3¼ in) long, maker Adrien-Jean-Maximilien Vachette, Paris, with the *Titre* for 1795-7 and engraved no. 5 on flange.

Provenance: Sotheby's, London, December 10, 1973, lot 39

For this maker cf. no. 52 of this catalogue.

The portrait is almost certainly that of Marianne de Bavière, Dauphine de France *after Mignard.* An identical miniature from the Collection of Louis XVI is in the Louvre since 1796 (Inv. 35696). The fashion of setting earlier miniatures of the Petitot-type of French boxes was initiated by Mme de Pompadour in 1752 (cf. The *Journal* of Lazare Duvaux, vol. II, p. 129, no. 116). Though belonging to a later period, this box still shows the popularity of such miniatures during the reign of Napoleon (for other examples cf. S. Grandjean, nos. 336/7, 357, 381 and 391/2).

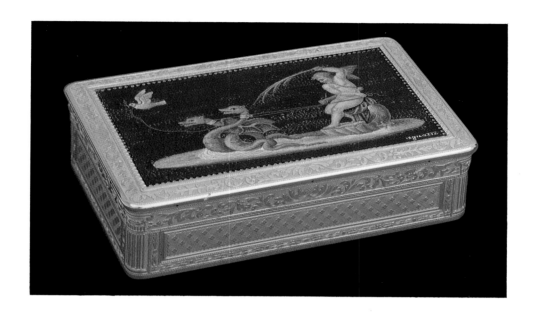

59

A Directoire Rectangular Gold-Mounted Mosaic Snuff-Box, the cover inset with a Roman micro-mosaic of Cupid seated on a shell drawn by a pair of sea serpents and a white dove, on a black ground, *signed aguatti,* the border chased with foliage on matted ground, criss-cross engine-turned sides and base with similar borders.

8.8cm (3⁷⁄₁₆ in) long, maker Pierre-André Montauban, Paris, with the *Titre* for 1795-97.

Provenance: Christie's, New York, June 20, 1980, lot 233

Exhibited: Cf. no. 39 of this catalogue for the itinerant exhibition at the Victoria and Albert Museum, London, and five American museums, 1977/9

Pierre-André Montauban (active circa 1800-1820), whose mark was only recently identified, was established by 1804 at 30 Quai des Orfèvres. He specialized in gold-mounted tortoiseshell boxes.

Antonio Aguatti (Aquatti), was active during the first half of the 19th century. His workshop was at 96 Piazza di Spagna. Member of the *Studio del Musaico della Città del Vaticano* (SVM) in 1829, he is mentioned as professor of the *Mosaici filati.*

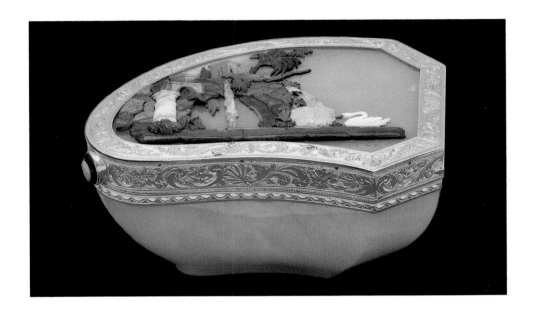

60

A Shaped Gold-Mounted Agate Table Snuff-Box, the pear-shaped cover applied in hardstones with a river landscape and a swan, inscribed beneath *S. Morelli F. in Roma via Della Scrofa N8,* the gold mount to the cover and the tapering pale agate body engraved with flowers and scrolling foliage, agate pushpiece.

9.5cm (3¾ in) long, maker Gabriel-Raoul Morel, Paris, with the *Titre* for 1795-97, the hardstone body by Giuseppe S. Morelli.

Literature: A. Gonzales-Palacios, no. 50

Exhibited: Christie's, London, *A Fanfare for Europe,* 1975, no. 294

Gabriel-Raoul Morel (1764-1832), mentioned as jeweller at 5, Place de Thionville 1806, mounted lacquer and glass boxes, and worked for the Napoleonic and Royal Court.

Similarly to Vachette he was eclectic in his choice of materials. Alongside his royal commissions (cf. no. 67 of this catalogue) he also produced objects in a more traditional manner such as nos. 64 and 65 of this catalogue.

Giuseppe Morelli, active during the first half of the 19th century, was a pupil of G. Raffaeli in Milano. His workshop was at 8 via della Scrofa. For another box with a hardstone panel signed Morelli cf. Christie's, Geneva, *Fine Objects of Vertu,* November 10, 1976, lot 240.

61

AN OVAL JEWELLED AND ENAMELLED GOLD ROYAL PRESENTATION BOX, the *sablé* cover applied with a double interlacing foliate monogram LP beneath a crown set with rose-cut diamonds, the frame with pale-blue ribbons and gilt and green enamel vine leaves on opaque royal blue ground, the sides and base engine-turned with a chequer-pattern within similar borders. The interior to the cover inscribed "The/gracious present of/His Majesty Louis Philippe I/King of the French/to Lt. Col. the Honble Sir Edward Cust K.C.H./upon the occasion of the marriage of/Leopold King of the Belgians/ with/the Princess Louisa of Orleans/Compiègne August 9th, 1892".

9cm (3½in) long, Paris, with the *Titre* for 1795-7, maker's mark FLC. *differend* a bird in a lozenge, retailed by Martial Bernard, inscribed *M^{al} Bernard rue de la paix no. 7* and no. 121 on flange, stamped no. 17 on base.

Provenance: Lord Brownlow, Sotheby's, London, January 20, 1975, lot 184

Louis-Philippe d'Orléans (1773-1850), eldest son of Louis-Philippe-Joseph, Duke of Orléans (Philippe Egalité), Duke of Chartres (1785), joined the Jacobin Club (1790), Commander of the Army of the North and Lieutenant General (1791), plotted to overthrow the Republic (1753). In exile he married Marie Amélie, daughter of Ferdinand IV of Naples (1809). He returned to France 1815, was exiled again and proclaimed King of France 1830. He abdicated 1848 in favour of his grandson.

Sir Edward Cust (1794-1878) general and military historian. From 1816 he was Equerry to Prince Leopold of Saxe-Coburg-Gotha, King of the Belgians (1832).

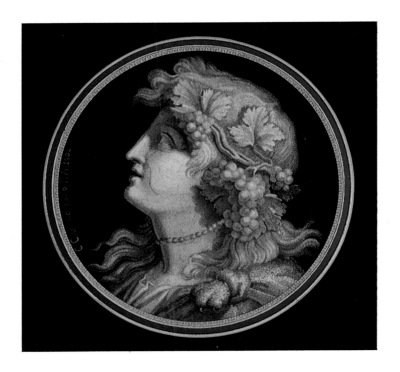

62

An Empire Circular Mosaic and Gold Box, the cover with a Roman micromosaic of the head of Bacchus *signed C. Ciuli Romano F.A. 1804,* in profile facing left, wearing vine and grapes in his hair, a pearl necklace and a panther-skin over his shoulders, on green background, with opaque blue enamel border, the base with a *basse-taille* blue enamel vase on burnished ground within an engine-turned band of concentric circles and an outer burnished gold frame with blue enamel bacchanalian trophies, the sides *en suite.*

8.3cm (3¼ in) diam., maker Adrien-Jean-Maximilien Vachette, with the *Titre* for 1795-7, engraved 87947 and stamped 756 on flange.

Provenance: Pope Pius VII, 1811
 Mr. Mussland (or Prussland)

Literature: A. Gonzales-Palacios, no. 31
 B. Hillier, *The Gilbert Collection of Mosaics,* The Connoisseur, CLXXXVIII, no. 758, April 1979, p. 273 (ill.)

Exhibited: Victoria and Albert Museum, *Mosaics from the Gilbert Collection,* London, 1975, no. 69
 Los Angeles County Museum of Art, *A Decade of Collecting,* 1975, no. 82 (col. ill. p. 88)
 For the itinerant exhibition at the Victoria and Albert Museum, London, and five American museums cf. no. 39 of this catalogue

For the maker cf. no. 52 of this catalogue.

Clementi Ciuli (Romano), active during the first half of the 19th century, was considered by contemporaries as one of the best micro-mosaicists specializing in monochrome. Particularly noted by his contemporaries was a head of Jupiter set in a snuff-box and dated 1803, today in the Museo Napoleonico (cf. Petochi, fig. 28). His workshop was at 71 Piazza di Spagna.

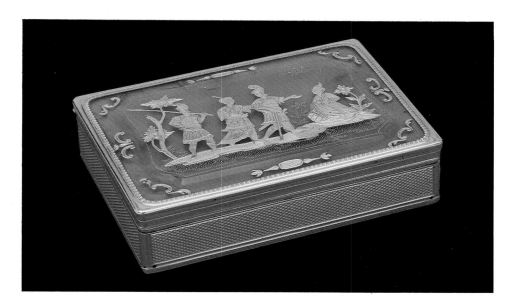

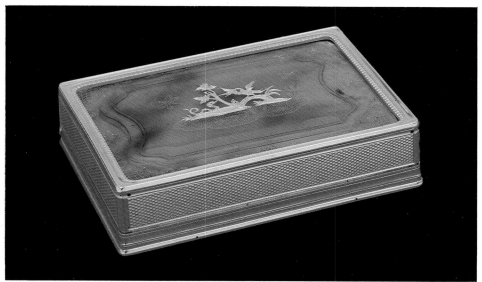

63

A Rectangular Tortoiseshell and Gold Snuff-Box, the cover inset with an *écaille blonde* panel décorated in *piqué point* and *piqué posé* with two Roman warriors and two Chinamen in a landscape with scroll motifs at the borders, the base with a similar panel decorated with a bird fighting a dragon in a river landscape, the sides engine-turned, with plain burnished gold mounts.

8.2cm (3⅛ in) long, maker Adrien-Jean-Maximilien Vachette, the flange inscribed: *Ouizille et Lemoine bijoutiers du Roi,* Paris, with the *Titre* for 1795-7 and 1809-19.

For the maker cf. note for no. 52 of this catalogue.

A good example of Vachette's eclecticism. In this case he mounted tortoiseshell panels of earlier date (c. 1730-50) in a typically turn of the century box.

64

A Rectangular Gold-Mounted Verre Fixe Snuff-Box, the panels painted with landscapes, cattle and shepherds *in the manner of van Berchem,* the mounts chased with stylized leaves and geometric motifs.

8cm (3⅛ in) long, maker Gabriel-Raoul Morel, Paris, with the *Titre* for 1795-97 and 1819-38.

Provenance: Christie's, London, December 18, 1973, lot 187
Christie's, Geneva, *Fine Objects of Vertu,* 26 April, 1978, lot 238

For this maker cf. no. 60 in this catalogue.

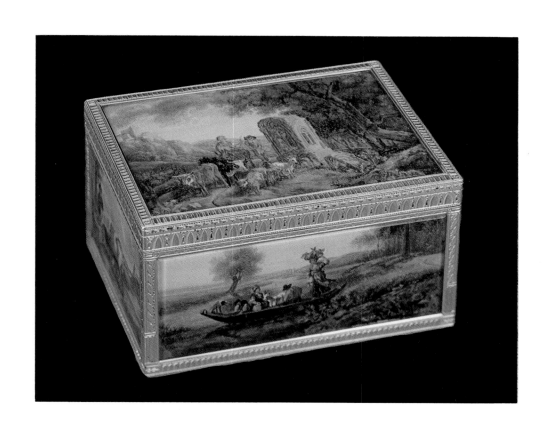

65

A Rectangular Black Lacquer and Gold Snuff-Box, the cover, sides and base with *lacque burgauté* panels decorated with a cockerel (cover), two ducks (base), flowers and foliage, all in autumnal colours, each panel set in a framework chased with stylised foliage and geometric motifs, with pilasters at the corners.

8cm (3⅛ in) long, maker Gabriel-Raoul Morel, Paris, with the *Titre* for 1795-7 and 1819-38 and stamped 549 on the flange.

Provenance: Jeremy Harris Esq., London

Literature: A. K. Snowman, col. pl. 424

For this maker cf. no. 60 of this catalogue.

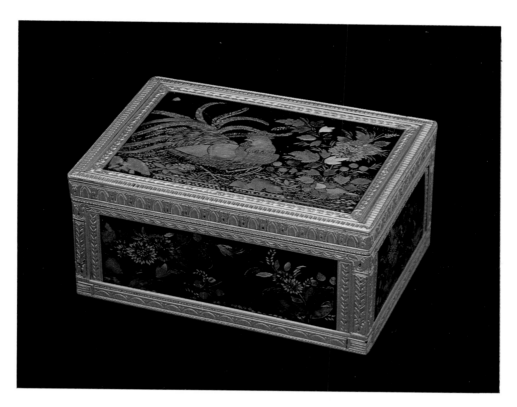

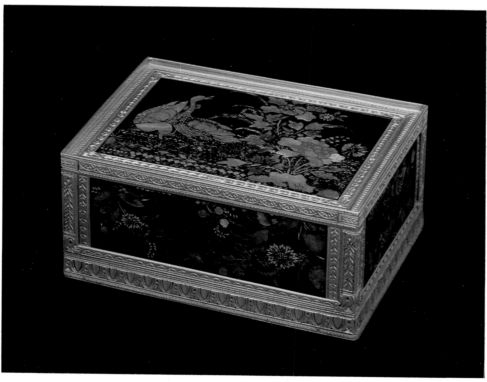

66

An Oval Gold-Mounted Porcelain Table Snuff-Box, the cover, base and sides set with Sèvres plaques painted in colours with amatory scenes *after Boucher,* the cover and base with ovolo borders, the sides with bands of raised pellets, the lip with double acanthus-leaves on matted ground alternating with triglyph capitals.

8.7cm (3 in) long, maker Jean Baptiste Fossin, inscribed on the flange *Fossin & Fils Joailliers du Roi à Paris,* Paris, 1819-1838.

Provenance: Viscount Bearstead, M.C.

Literature: A. K. Snowman, ill. 420
 R. and M. Norton, p. 22

Exhibited: *British Antique Dealers Association Golden Jubilee Exhibition,*
 Victoria and Albert Museum, London, 1968, no. 24 (ill.
 pl. 36)

The miniature on the cover is after *Le Berger et la Bergère* now in the Wallace Collection, London. A similar miniature in a Louis XV frame from the Elisabeth Parker Firestone Collection was sold by Christie's, New York, November 12, 1982, lot 36.

Although traditionally held to be by the hand of Dodin, the finely painted porcelain panels of this box would seem to date from the early 19th century. Mrs. Tamara Préaud of the Manufacture Nationale de Sèvres has very kindly researched the registers of the Manufacture until 1815 without finding any related type of object. Beyond 1815 and for the period of 1819-39 manuscript documents need yet to be analysed. It is highly unlikely, however, that the panels of this box should date from the 18th century and have survived unmounted for five decades before being mounted.

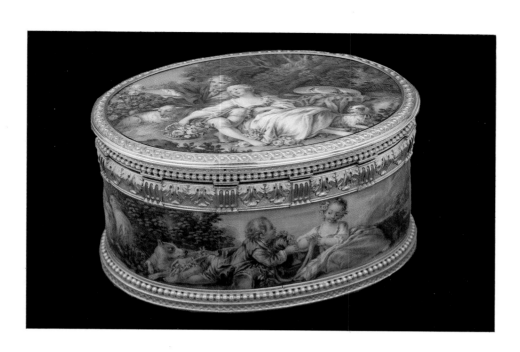

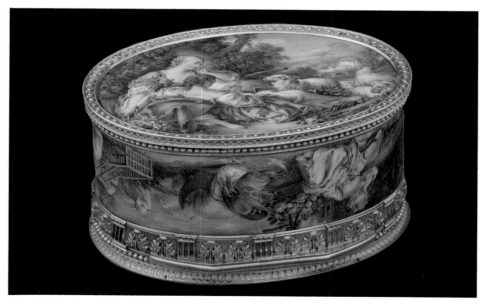

67

A Louis Philippe Rectangular Gold Presentation Box, the cover applied with a ducal coronet and foliate interlacing monogram LO, the body engraved with scrolling foliage and strapwork on matted ground, the cover inscribed on the interior 'Presented by/H.R. Highness Louis d'Orléans/Duc de Nemours/to/Charles Locock, M.D./February 23rd, 1849', with interior lidded compartment.

9.1cm (3½ in) long, maker Gabriel-Raoul Morel, Paris, circa 1848, engraved 236 and stamped 904 on flange.

For this maker cf. no. 60 of this catalogue.

For another presentation box also by Morel with identical monogram, cf. Christie's, New York, July 7, 1982, lot 23.

The initials are those of Louis d'Orléans (King Louis Philippe of France) who abdicated 1848 and lived in England at Claremont House. For his earlier biography cf. no. 61 of this catalogue.

The presentation of this box is almost certainly connected with the sickness of the Royal Family in late 1848 due to serious lead poisoning from the pipes at Claremont House. The Queen was still convalescent in early 1849.

Sir Charles Locock (1799-1875), became a Doctor of Medicine at Edinburgh in 1821 and a Fellow of the Royal College of Physicians. Physician Accoucheur of Queen Victoria from 1840, created Baronet in 1857, he died 1875. Sir James Paget described him as having great powers of work and devotion to duty, quick keen insight and great practical knowledge of his profession.

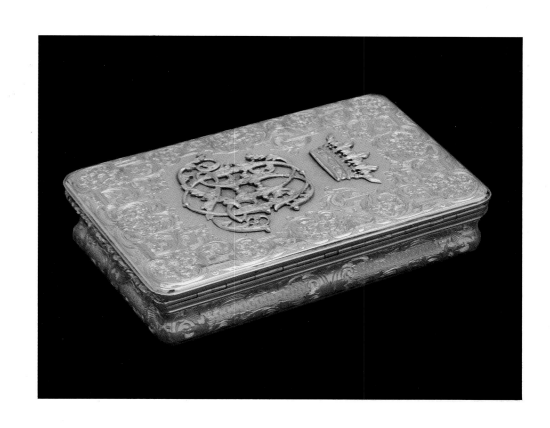

68

A Rectangular Gold Table Snuff-Box, the cover inset with a miniature on parchment of a firework display on a river watched by numerous ladies and gentlemen in boats and from shore, a castle and church spire in the background, *by van Blarenberghe, signed and dated 1761,* the base with a miniature of the interior of an opera house, a play being produced on stage to a large assembly of elegant ladies and gentlemen, the sides engine-turned with reeding and chased with trailing ivy, suspended garlands of roses and musical trophies.

8.2cm (3¼ in) long, the box circa 1870.

Provenance: The two miniatures were sold (unmounted) in the second Demidoff sale, Paris, January 13-16, 1863, lot 33, for 10,750 gold francs (to M. Cambacérès).
Christie's, Geneva, *Fine Objects of Vertu,* November 17, 1981, lot 168

Literature: Benezit I, 1966, p. 696

A large number of finely painted miniatures signed *van Blarenberghe* without an initial are known to us. At least five members of this family were painters and of these Louis-Nicolas (1716-1754) and his son Henri-Joseph (1741-1826) are inseparably linked. Louis-Nicolas was a *protégé* of the Duc de Choiseuil. Painter of marine and military subjects, he was celebrated for his gouaches of many figures in architectural settings. His son was drawing-master to the Royal children and collaborated with his father to an extent that their work can only rarely be differentiated.

According to M. Serge Grandjean of the Musée du Louvre, who has kindly offered this information, only two miniatures by van Blarenberghe bear the same date, both on a box by Jean George in the Hermitage, Leningrad. Mr. Grandjean has identified the façade on the right as that of the old Palais Bourbon on the Seine built 1772 by Ghirardini for Mlle de Nantes, legitimised daughter of Louis XIV and the Marquise de Montespan. On the left can be recognised one of the Pavillons and the small tower at the entrance of the Cours-la-Reine near the Place Louis XV (today Place de la Concorde). The bridge at that time was not yet built. The second miniature, unique in Van Blarenberghe's oeuvre, cannot be identified with certainty, but would logically be connected with some royal theatrical representation.

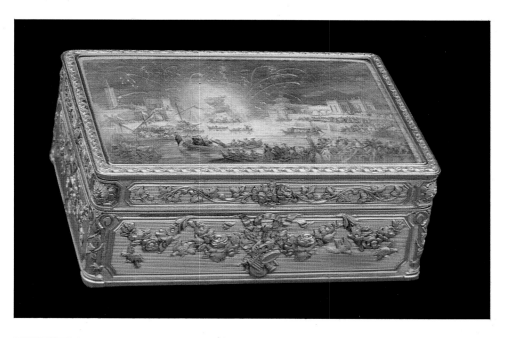

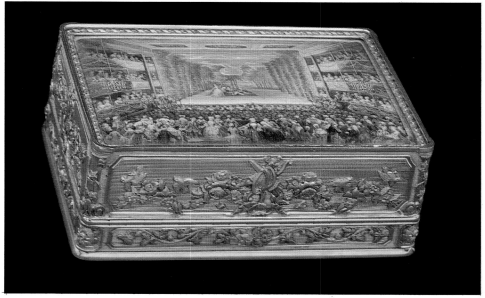

BIBLIOGRAPHY

The following abbreviations have been used in the text:

Berry-Hill

Henry and Sidney Berry-Hill
Antique Gold Boxes, Their Lore and Lure, 1953

Le Corbeiller

Claire le Corbeiller
European and American Snuff-Boxes, 1730-1830, 1966

A. Gonzales-Palacios

A. Gonzales-Palacios
The Art of Mosaics. A Selection from the Gilbert Collection, Los Angeles County Museum of Art, 28 April- 10 July, 1978

S. Grandjean

Serge Grandjean
Les tabatières du Musée du Louvre, 1981

S. Grandjean
The Waddesdon Catalogue

Serge Grandjean, K. A. Piacenti, C. Truman, A. Blunt, *The James A. de Rothschild Collection of Waddesdon Manor, Gold Boxes and Miniatures of the Eighteenth Century*, 1975

R. and M. Norton

Richard and Martin Norton
A History of Gold Snuff-Boxes, 1938

D. Petochi

Domenico Petochi
I Mosaici Minuti Romani dei Secoli XVIII e XIX, 1981

H. Ricketts

Howard Ricketts
Objects of Vertu, 1971

A. K. Snowman

A. K. Snowman
Eighteenth Century Gold Boxes of Europe, 1966

A. K. Snowman
The J. Ortiz-Patiño Catalogue

A. K. Snowman,
Eighteenth Century Gold Boxes of Paris. A Catalogue of the J. Ortiz- Patiño Collection, 1974

Further bibliography will be found in the Catalogue notes.

HALL MARKS

Box 1

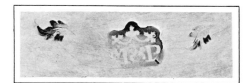

Box 2

Box 4

Box 5

Box 6

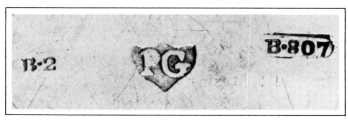

Box 7

Box 11

Box 20

Box 21

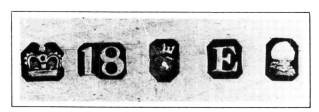

Box 24

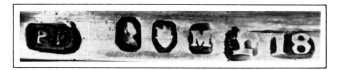

Box 27

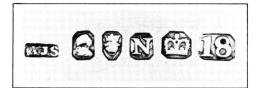

Box 29

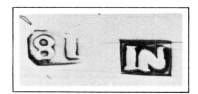

Box 31

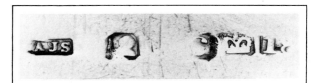

Box 32

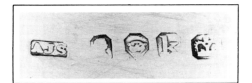

Box 33

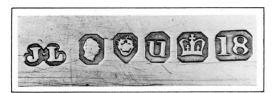

Box 34

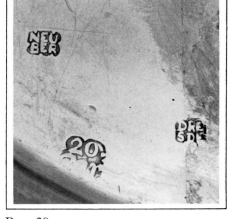

Box 39

Box 44

Box 46

Box 42

Box 47

Box 48

Box 50

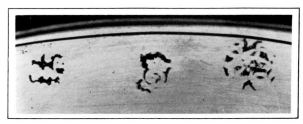

Box 51

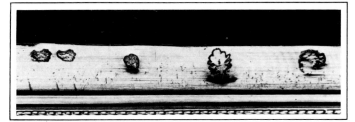

Box 52

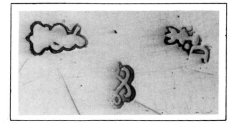

Box 53

Box 55

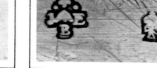

Box 57

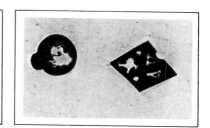

Box 58

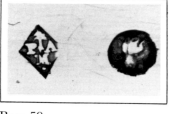

Box 59

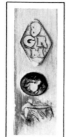

Box 60

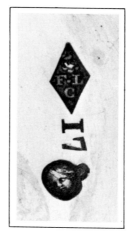

Box 61

Box 63

Box 64

Box 65

Box 66

Box 67

INDEX

NOTES